OIL PAINTING BASICS

An Artist's Guide
to
Mastering the Medium

TIMOTHY EASTON

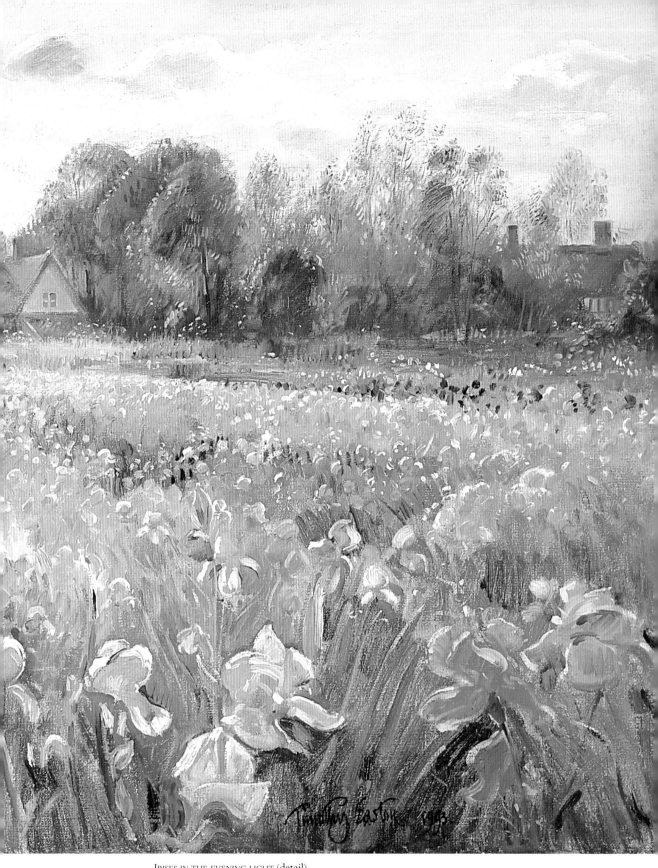

IRISES IN THE EVENING LIGHT (detail)

OIL PAINTING BASICS

An Artist's Guide to Mastering the Medium

TIMOTHY EASTON

Watson-Guptill Publications/New York

DEDICATION

For my parents

ACKNOWLEDGEMENTS

To John Lidzey and the John Russell Gallery, Ipswich, who introduced me to the publishers. I should particularly like to thank Mary Nesling and Joanna Martin for assistance with typing and proof-reading, and Philip Richards who photographed all the paintings. I should also like to acknowledge the three members of the editorial team who gave guidance and shape to my text: Ros Dace, Abigail Glover and Emma Clegg.

First published in the United States in 1998
by Watson-Guptill Publications,
a division of BPI Communications, Inc.,
1515 Broadway, New York, NY 10036

Library of Congress
Catalog Card Number: 98-85573

ISBN 0-8230-2712-0

First published in the United Kingdom
in 1997
by B T Batsford Ltd
583 Fulham Road
London SW6 5BY

Printed in Hong Kong

First printing, 1997

1 2 3 4 5 6 7 8 9 / 06 05 04 03 02 01 00 99 98

Designed by DWN Ltd., London

Contents

INTRODUCTION

It is thought that oil painting techniques were first developed around AD 1200. Pigments had previously been bound with egg or glue and the introduction of oils allowed artists greater freedom to capture rich effects with saturated colour. No other medium has yet challenged the 800-year supremacy of oil paints. They can be combined to capture the effects of light and texture; their flexibility enables them to be blended; and, when used correctly, they are very stable.

Manufactured oil paint first became available in metal tubes in the nineteenth century. It was at this time that the practice of working directly from a subject in the open air was pioneered by the French Impressionists. This new freedom encouraged radical changes in techniques, building up thick textured, stippled and patterned surfaces. Artists in the twentieth century have continued to experiment, using a wide variety of matt and glossy paint finishes. Students of painting can therefore try out a vast range of techniques.

A painter's response to a subject involves a balance of emotion and ideas, the discipline of observation and the choice of techniques which will express their intentions. Just as the ideas of a composer or an author cannot be expressed without the grammar of notation or word structure, so artists working in oils need to know the full possibilities of the techniques through which they can transmit their ideas and emotional responses.

All artists feel intense pleasure when their mark-making succeeds in expressing their intentions and ideas. Rather like the 'high' that a musician or actor must feel when a performance sweeps to a climax, moments such as these sustain the painter through the hours of struggling with transitory light effects, or ideas that won't quite materialize. To be able to express yourself, you must be able to use the basic grammar of art – to understand colour and tone, form and line and textural effects.

If you are taking up oil painting for the first time, you need to have enthusiasm which, with constant practice, may be developed into something more. It is more difficult to teach ideas, but these will come from your own experiments and from a growing familiarity with the techniques used by artists in the past. Painting and drawing is a way of arriving at a deeper understanding of a subject and of communicating your own personal vision.

I aim to show you how to select and lay out your subject. Each chapter will suggest what to search for in your compositions and how to analyse and inform yourself of the many possibilities; which colours to select for particular effects and how these can be simplified to achieve a convincing result. As you practise, you will find that you will gain a greater insight which will allow you to communicate your enthusiasm and enjoyment. Try not to be too ambitious to begin with, so that you can, above all, enjoy the process of painting in oils.

WATERFRONT FLAGS 30.5 x 20.3 cm (12 x 8 in.)

Timothy Easton. 1992

Equipment

If you have come to this book with no experience of working in oils, the first suggestion is to keep everything simple to begin with. The range of materials displayed at art fairs and in good art stores is bewildering and it is a waste of money to buy too much studio furniture and too many colours until you know what you really need.

The equipment used in most artists' studios before the nineteenth century was comparatively simple, but imagination and skill can translate a limited palette into a masterpiece. Once you have familiarized yourself with a few favourite materials, you can then concentrate on developing the ideas for your paintings rather than worrying about the ingredients.

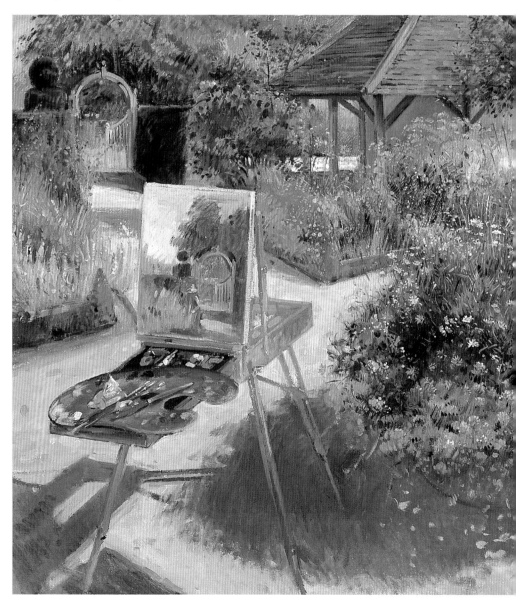

EASELS

There are three main types of easel, but the largest studio easel with an all-square base on castors is probably too big for many homes. The smaller collapsible three-legged easel is a good sturdy companion in my studio, but if I had to choose just one then I would go for a folding outdoor easel box. You can store your paints, brushes and palette inside and it does not take up too much room when folded down. The one limitation is the height of canvas that it will take, a maximum of 84 cm (33 in.), though a 76 cm x 1 m (30 x 40 in.) canvas could make quite a statement. The latter two types of easel are included in the painting shown below.

PAINTING SURFACES

Although I have used different materials to paint on since my student days, beginning with primed paper and prepared hardboard (Masonite), my preferred choice for all the paintings in this book is canvas supported by a stretcher. The material comes in different weaves and thicknesses, and if bought already prepared it will have varying applications of grounds. Each responds to the brush in a special way and the different surfaces may require a change of technique to suit the feel of that material. A triple-primed canvas will obscure much of the weave and give a smoother surface appropriate to fine detail (see pages 32–3). A single ground will allow you to feel more of the tooth and perhaps encourage a drier dragged quality using less medium.

Once you have discovered which of these you favour, you could try producing something similar using hardboard, canvas boards or muslin stuck to hardboard with rabbit-skin glue. These three alternatives are more economical than best linen canvas and are ideal for making panels to use on small, directly observed studies.

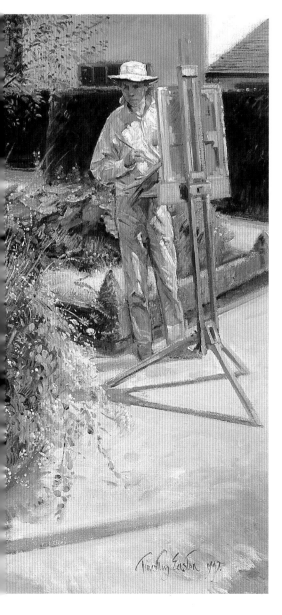

THE CROSSING 40.6 x 61 cm (16 x 24 in.)

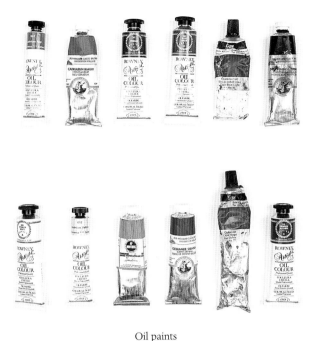

Oil paints

PALETTES

Most palettes seem to work better once they have been in use for a while. The traditional material of wood absorbs the oil from the paint and creates a surface which resists the sinking and staining that is noticeable when first used.

Although many are designed to be held, don't feel obliged to do this. If you are going to hold a palette of any size, then try out a few to find one with a good balance. I often find it helpful to rest the palette on a table beside me in the studio or on the easel box when working outside. Many of my colours are pre-mixed with a palette knife before starting a painting. This can encourage a cleaner approach. When holding a palette, it is not difficult to use the brush to mix as you go along, but in an inexperienced hand this may become confused with mixing paint on the canvas, which can lead to a messy surface.

PAINTS

It is worth buying good quality artists' oil paint and also trying out different makes. There is a tendency to use too much oil in tubes and the amount can vary greatly with each manufacturer. So too will the fillers and extenders which are added to the pigment; as a rule the less expensive the paint, the more reliance there is on bulking agents. Theoretically, the more pure the colour, the less you require to obtain luminosity. Whilst you cannot alter bulk-filled paints, you can dry off some excess oil medium by putting your pigment on to blotting paper.

Student oil paints are less expensive because they contain cheaper pigments and more extenders and so they don't have the richness of colour.

It is also worth noting that the hue of a certain colour can vary quite considerably among manufacturers. For example, a colour such as yellow ochre may appear as a pale sandy colour in one make while in another it will look more like raw sienna.

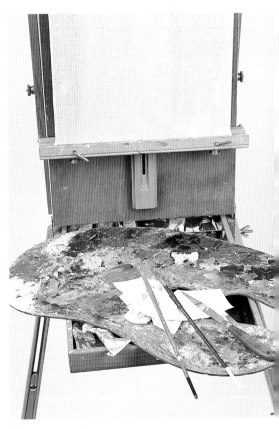

Palette on easel

Alternatively, you could try using a thick sheet of glass, with the edges and corners rounded off. One advantage of this is that when you are painting on a washed ground colour of your choice (see page 17) you can place a piece of similarly coloured paper beneath the glass, so allowing your mixed colours to appear against the same background.

SETTING OUT AND PRE-MIXING COLOURS

Each artist develops his or her own arrangement for setting out the colours and then mixing them. Once you find a system you are happy with, this becomes a little like operating a typewriter or computer keyboard – you will go to the spots automatically. A common method which I use is to start with white and proceed with yellows, working progressively darker in tone around the top of the palette. On reaching the reds and crimson, the opposite colour on a colour wheel, green (the complementary colour), is placed next. I then move on through the blues and purples to black.

Some of these colours, such as greens, you may wish to mix yourself. Initially I would recommend that you use a smaller range than is shown on my palette. In most instances I would only set out about half these colours and add extras only if really essential. In the exercise described on pages 22 and 23, only five colours plus white are used.

Below the principal tube colours arranged at the top of my palette, I add a range of further mixed colours, based on what I see before me. These are always prepared in advance using a palette knife. It is from these pre-mixed colours that my brush selects and blends the paints that go on to the canvas.

SUGGESTED COLOUR LIST

Main colours included on my palette:

- Titanium white
- Cadmium yellow
- Raw sienna
- Burnt sienna
- Alizarin crimson
- Viridian
- Cobalt blue

Alternative or additional colours:

- Cadmium lemon
- Yellow ochre
- Raw umber
- Burnt umber or Vandyke brown
- Indian red
- Cadmium red
- Sap green or olive green
- Cerulean or ultramarine
- Permanent mauve
- Ivory black
- Blue black

TIP

Turpentine and white spirit can remove the natural oils in your hands and make them more susceptible to the harmful effects of some paints. Try using vegetable oils, such as sunflower or cooking oil, which will clean while reducing the risk of skin damage.

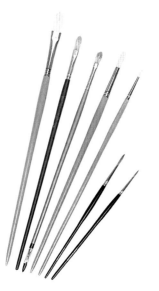

Selection of brushes

BRUSHES

Hog-hair brushes are relatively inexpensive, so get a good selection. The size and shape you choose will probably vary according to the dimensions of the canvas you are working on. The type I favour, and have used a lot in these paintings, are filbert brushes, usually varying between sizes 1 and 4. Hog-hair brushes are ideal for laying in and working on the main passages of a painting, while sable brushes might be used to add fine detail.

The very best sable brushes are expensive, but if looked after are definitely worth having. You will only need a couple to begin with – perhaps a size 1 and 3. Cheaper alternatives tend to splay after use, with fine hairs coming out as you paint. It is traditional to have a long-handled sable for oils, but I find that a short-haired watercolour brush can be as useful, particularly for the initial drawing-in of the subject as well as for highlighting at the end. If you wash all your brushes after use in warm soapy water they will hold their shape and continue to do the job you bought them for.

PALETTE AND PAINTING KNIVES

The palette knife which I prefer to use is one with a long blade that is not too rigid and does not have a cranked handle. The blade is usually made from flexible tempered steel and as it ages it develops sharp edges, which are ideal for scraping the excess from the palette as well as for mixing the paint.

A more delicate tool than the palette knife, the painting knife resembles a small trowel and was designed specifically for the application of paint. One with an elongated, diamond-shaped blade is helpful for removing unwanted paint from an area of canvas if it has become clogged.

Palette and painting knives

OTHER EQUIPMENT

You will require a tin, jar or pot to put your turpentine into and if you are holding a palette you may prefer a dipper (palette cup) to clip on.

You could make yourself a set of four viewfinders which will be helpful when deciding which part of a view you wish to concentrate on. Cut some rectangular holes of varying proportions in black card to match the proportions of the canvas that you are using; make them large enough to hold at arm's length and with these you can isolate the section of the landscape you want to paint.

A plumb-line – simply a weighted string – is a great help in establishing vertical lines of buildings and to help assess the angle of a leaning tree.

The last essential piece of equipment is a small pocket sketch book to set down simple drawings that can convey the essence of something you have seen, perhaps your different views of the landscape glimpsed through the viewfinder. This is explored on pages 16 and 17.

These items can all be packed in your box easel with paints, brushes, palette and rags, and can be carried straight from your painting room to the exterior landscape, providing you with all you require to start work.

Mahl Stick

This piece of equipment you may find useful if you are putting in areas of detail. Traditionally this comes as a long cane or stick, with a cork end covered with chamois leather that can be rested on the side or top of the canvas, providing a support for your painting hand. For outdoor use you should be able to buy a more portable aluminium version with a rubber tip which is made in three sections – this will screw together and fit into your paint box.

Claude Glass

Traditionally a Claude Glass is a darkened piece of glass, which makes an imperfect mirror allowing you to see a reflected image in tone rather than colour. Nowadays a practical alternative is to use an offcut of acrylic and paint the reverse with a couple of coats of black paint. This will enable you to view bright passages of water or clouds in reverse and distinguish the tonal range. Cover the black painted side with masking tape so that when it travels in your easel box it does not become scratched.

Mahl stick and plumb-line

Techniques

Techniques for use with oil paint consist both of those skills which are essential for artists working in any media, such as sketching, perspective, composition and using tone and colour, and those techniques such as scumbling, dry brushing and glazing, which are specific to oil paints and make the medium such a rich and versatile one to work with.

UNDERSTANDING PERSPECTIVE

In an urban setting, perspective can be more easily understood than in an open landscape. As a subject, town buildings are not covered in this book, but when painting a landscape it is worth noting any parallel lines that converge on a vanishing point. This feature will lead the eye into the composition and give the illusion of greater depth.

I do not intend to give a full account here of all the ways in which a sense of perspective can be conveyed, as you will be able to find such information in more specialized books. In essence it can be simplified into two main forms: two-point or oblique perspective and single-point or square perspective. The latter can be seen at its simplest with a railway track stretching away into the distance with some telegraph or fence posts on either side (see below). In reality this is rarely so clear-cut in the landscape but in the painting *Watching from the Wall* (see page 25) the parallel rows of vines, stretching directly away below the elevated town wall, take the eye quickly from the foreground to the middle distance. *Chessboard*, the painting opposite, is also based on single-point perspective.

Pages 8–9 show an example of two-point perspective in the landscape, *The Crossing*, where the planted copper container is placed near the centre of the composition with the two converging paths stretching away from it on both sides. If you are using this device, you require a strong feature to dominate the crossing point and hold the eye, otherwise there is a tendency to wander between the two distant points and lose the central area of concentration. Here, the inclusion of the two easels helps to control the view towards the middle portion of the composition.

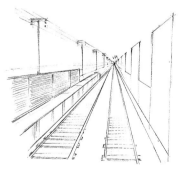

Illustration of single-point or square or parallel perspective going towards one vanishing point

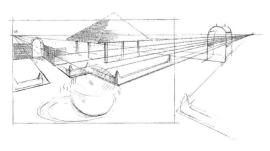

The Crossing: two-point or oblique perspective converging on two vanishing points

The main thrust of the perspective lines in the painting *Chessboard* is towards a single point, but if the shadow lines were projected these would also meet at another distant point. This canvas was painted in my studio using much smaller studies that were made in a very confined space. If I had initially tried to paint this on a larger scale the canvas would have blocked my view and cut out the light.

The original study for this painting was made before I began the oil painting. Drawing is not only about mark-making and is not just a record of what you see. Time spent working on a drawing will allow you to understand the structure and ask questions about how it works and how you might wish to alter it. Notice how the walls and window bars have been adjusted on the painting.

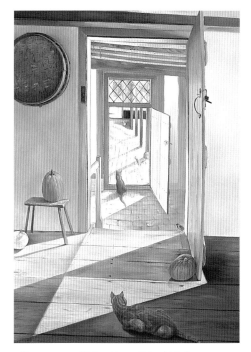

CHESSBOARD 91.5 x 61 cm (36 x 24 in.)

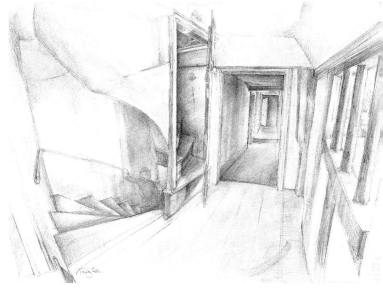

THE EMPTY CORRIDOR (detailed drawing)

During the afternoons spent observing the subject, small incidents involving the cats and birds were recorded and then incorporated into the final composition. The complicated cross-lit shadows formed patterns which, when the animals and objects were positioned within them, suggested a game in progress.

At first glance *The Empty Corridor* may seem to go towards a single point, but it is also based on a two-point perspective. The projected lines made by the stair-treads against the wall and the return at the top of the door frame would eventually meet at a single distant point.

THE EMPTY CORRIDOR 51 x 76 cm (20 x 30 in.)

COMPOSITION AND DRAWING

Whatever you choose to paint, it is worth spending time making some drawings of the subject in your sketch book. This will allow you to familiarize yourself with the shapes and positions of the elements in your subject in relation to one another. It will also allow you to use artistic licence to alter their positions slightly if it enhances the overall composition.

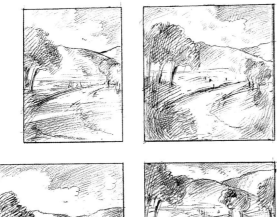

Four diagrams of a river landscape showing how your viewfinder can help you select proportions. Notice how the mood seems to be changed by the shape and balance of sky to land

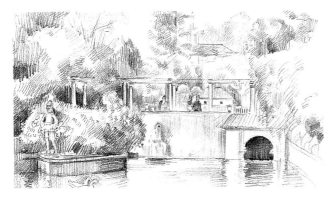

Pazo da Oca, near Santiago de Compostella
An hour's drawing that, with other detailed studies, provides enough material for a studio painting

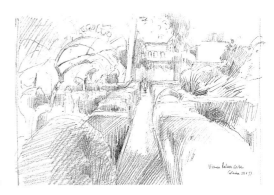

Viana Palace, Cordoba A 20-minute drawing of a formal garden establishing the main features in preparation for a painting

Selecting a Viewpoint

Your studies do not need to be detailed but rather should give an overall idea in line and tone. This not only enables you to gain experience of the general shape of your subject, but also helps in deciding which parts of the composition you wish to emphasize. Remember that your eye is only able to focus on one part of a wide view at a time, so you can experiment as to which areas can be left to recede in order to give greater definition to a focal point. It is during these initial investigations that your viewfinders will help to sort out the possibilities of form and content. With a landscape or seascape, the drawing process can also help you to establish your horizon and how much sky you intend to show.

Preliminary Sketches

Once you have found a particular view that catches your attention, make some rapid tonal drawings to familiarize yourself with the range of possibilities from that position. Before you start painting try walking in other directions around your subject. Apart from deciding whether your first choice was the best and only option, you will also learn more about the hidden areas when viewed from the side. Also, you need fully to understand what effect a change in the direction of light will do for the composition.

TONAL STUDIES

If the sun is shining to the side of your subject, you will have greater contrast and definition of shapes. With the light behind you, everything before you will be well lit but with little modelling. When the sun is in front, you will be more aware of tones than colours. Against the light, the shadows coming towards you may clarify the direction of the perspective and will give more spatial depth to your composition.

Try to see your subject tonally, from darks to lights rather than one colour against another – this will help to simplify things. The Claude Glass (see page 13) will help you to separate out the tones. You may find at first that you misinterpret some of your tonal values. For instance, imagine you are painting a coastal scene with large areas of water and sky. A calm sea will often appear darker than the sky, but lighting conditions may change so that these tonal contrasts, or parts of them are reversed (see the painting on page 45).

PREPARING YOUR CANVAS

Having selected your subject and the shape you feel is appropriate, you can now choose your canvas.

I put a wash on my canvases to cover over the white surface, a process known as *imprimatura*. This is done by mixing up a selected colour blend with turpentine, brushing it on and then wiping it off with a paper towel or rag after ten minutes or so. I like this surface to be completely dry before starting work, so leave the washed canvas for a day or two in summer or up to a week in winter. You will soon find which base colours work for you, varying between a pinkish-red and olive green. By selecting a mid-tone, both your dark and light brushmarks will register clearly as you set them down. A large area of whiteness can be inhibiting, so the wash will have broken the 'ice'. If you choose a complementary colour, small passages of the underpaint can be left to show through broken passages of the upper paint, giving a 'lift' to your marks.

Diagram showing the effect of strong high sidelighting from the right. The cast shadows help explain the forms

Sun high up behind the building puts the front into shadow. The backlighting of the trees radiates shadows, giving perspective

Diagram showing sunlight from a low angle shining on the front and part of the side – this does nothing to help explain the forms

Diagram showing a simplified building, side lit from the right, pencilled in tone with a minimal use of line

If you are unsure about
the balance of the light
and dark masses in
your composition,
check this either by
turning the canvas
upside-down and
standing back from it,
or by viewing it
through a mirror. Your
eyes will have become
accustomed to the
composition and seeing
it in an unfamiliar way
should help you to spot
any imbalance.

EXERCISE – DEVELOPING A PAINTING

The first illustration shows the early stage of a painting, produced in a two-hour session and is a good example showing *imprimatura*. The finished work shown here took four evenings to complete. You could create a similar composition or apply the development of the blocking in techniques shown here to another subject.

COLOURS
- **Yellow** – cadmium yellow
- **Red** – cadmium red
- **Blues** – cerulean blue and cobalt blue
- **Greens** – olive green and sap green
- **Other colours** – raw sienna and burnt sienna

BRUSHES
- Hog-hair filberts sizes 2, 3 and 4
- Sable sizes 2 and 3

Stage One

1 The base colour, which was applied to a double-primed canvas, is a wash of olive green and is clearly seen in the centre of the planted copper bowl. The first drawing lines, made with a sable brush

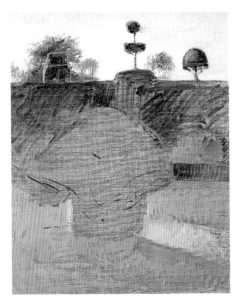

CENTREPIECE, stage 1

using a darker version of the same colour are also visible in the central unpainted section. (Some artists use charcoal for their first marks, dusting or blowing off the surplus, before enforcing the marks with painted lines.)

2 The hedge was blocked in with a wash of similar colour, using a hog-hair brush to create the contrasting dark areas. Up to this point the picture was almost in monochrome.

3 The first main areas of colour were introduced in the sky and warm shadows on the ground. The light was perfect that first evening and highlighted the topiary shapes, so I concentrated on these. I do not always work in this order, but I judged that the weather would be stable for a few days, and knew I could replicate the lighting conditions for the main flower section of the painting on other evenings. The next day I adjusted the drawing of the copper bowl in the centre of the painting, as I had initially misjudged its depth.

Stage Two

1 I chose to begin when the summer sun was setting between 8 and 10 pm. You will find that such an evening light softens the forms. You can translate this in the painting; in this case the flowers are muted so that some appear as blocks of colour while others are separately defined. This helps to accent the uppermost daisies and creates a filtered light passing diagonally across the plants. The shadows on the ground echo this and soften the lower corners. The dark clipped yew hedge not only creates a foil for the highlighted flowers but also shadows the border between middle distance and foreground so that the painting here does not detract from the main subject.

2 The topiary is a strong feature in this painting – look out for features like this and use them to your advantage. I placed deliberate emphasis on the topiary, particularly the triple-layered bush. By placing the copper slightly off-centre to the left and the cut bush to the right of the central axis, a dialogue is set up between the two forms. This helps define the setting to begin with, while still taking in the main object of interest. In the first laying-in, the shape of the cut hedge against the pale skyline is emphasized before starting on the planted copper. If you half close your eyes on the finished painting you will see that it is the clipped trees that you notice first, but because there is little detail here when viewing normally, the domed planting of daisies holds your attention, while you are also aware of the recessed background shapes.

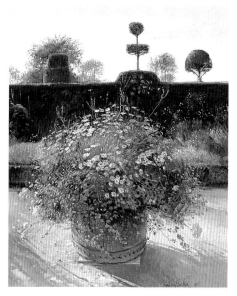

Centrepiece 61 x 51 cm (24 x 20 in.)

SCUMBLING

This refers to a thin layer of opaque paint which is used to block in areas loosely at the start of a painting (the underpainting) or which is applied over thicker dry areas of colour. The latter process might be used if a colour is too vibrant and a thin scumbled veil will 'knock it back'. It can also be used to create the effects of mist and fog (see page 47). The paint used for this process needs to be 'lean', meaning that it is thinned down with turpentine rather than oil. (An example of scumbling is shown right and see also page 45.)

TIP

Take another painting that you are not intending to keep and experiment with turps-based washes using a broad brush to see the potential effects of scumbled paint. Apply some thicker paint nearby so you can appreciate the range of options available.

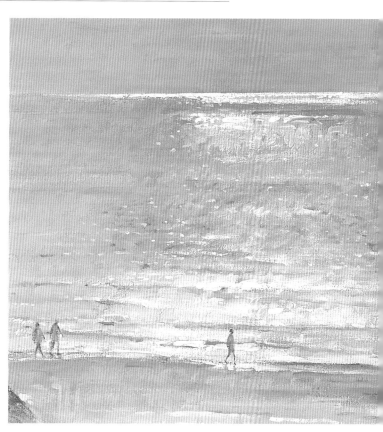

Beachwalk (detail)

DRYBRUSHING

When you drag a bristle brush across a textured surface with paint that has been blotted on absorbent paper, you will leave a broken brush mark. This effect will be increased if you use a fan-shaped brush or if you spread the bristles. It can be used to create areas of grass or feathers, for example, where you do not want to paint each strand individually, or for high wispy cirrus clouds over a dry, blue sky.

The example here shows an unlined muslin curtain which half obscures the view beyond. The landscape and window frame were partly painted with some of the billowing curtain and allowed to dry. Dragged, dry paint was then applied over this for a semi-transparent look. A similar example can be seen on page 85.

EASTERN VIEW (detail)

TIP

When painting a sky with cumulus clouds, mix the highlights with some thick white paint with a hint of yellow. You might try flake white, which is stiffer than zinc or titanium. Apply this as an impasto using a hog-hair brush on areas which have most reflection from the sun. A greater definition will be achieved by setting this against darker, thinner passages.

IMPASTO

This describes paint applied with a brush or a knife that is put on with thick luscious slabs. On the principle that paint is built up 'fat' (with oil) over 'lean' (thinned), impasto is usually added towards the completion of a picture to give due weight to a modelled area in contrast to thin adjacent passages. It has also been used to make caked strokes set down in rhythmic patterns – Van Gogh's paintings are distinctive for using this method. (An example of impasto is shown here.)

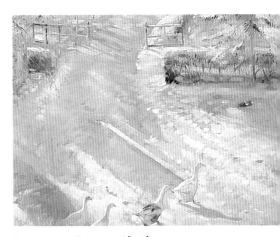

BETWEEN THE SHADOWS (detail)

ALLA PRIMA

Meaning 'at the first try' this describes a painting completed in one session with paint used wet-in-wet. If paint is allowed to dry and other brushmarks are added later, these can be crisp and distinctive. By working into wet paint the effects are softer and each area of colour applied is modified by the one underneath.

Remember you cannot continue a painting over two days using this technique.

Restrict yourself to a small canvas to begin with and try to limit the complexity of your subject. An *alla prima* painting will look fluid and sensuous and uses the skills of hand and eye that have responded spontaneously to an observed subject. As well as the detail shown opposite, see pages 34–5 for an example of this technique.

GLAZING

This process uses a transparent film of clear colour which is applied over another without obliterating it. It allows the quality of the painting to be enriched, softened or modified. Each level has to be dry, so this is used in more controlled studio conditions than *alla prima*. The more transparent pigments (and those without white) are cleanly mixed into a glazing medium (which can now be bought already prepared) and applied selectively to enrich specific areas. This was most notably used by fifteenth-century painters of the Netherlandish school, like Jan van Eyck, to create rich-coloured fabrics and later by Rembrandt to modify and soften thick impasto on skin. (See an example of glazing right and the full picture shown on page 32–3.)

USING DIFFERENT BRUSHES

Various lines and marks can be achieved with different types of brush. The contrast between a thick opaque mark made with a hog-hair brush and the thin drawn line produced by a sable is notable. Bristle brushes will each give individual effects. There are three main types: round, flat and filbert brushes. The first is suitable for applications which do not require a specific edge. Flat brushes are for the more distinctively shaped brushmarks. The filbert brush is very versatile as it has a soft edge and a point. Sable brushes when used with oils are useful for small highlights, applying glazes and line-drawing.

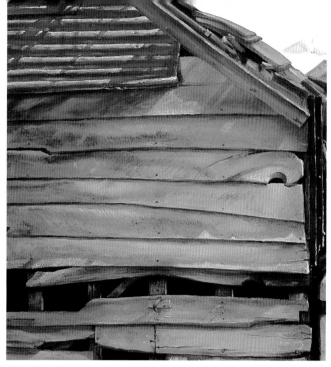

SCAVENGERS (detail)
The decaying boards are painted with a build-up of texture and detail. When completely dry, a green glaze is applied with a sable brush to achieve a luminous glow. A rich dark glaze is also applied to the barn interior glimpsed through the boards and in the recesses for contrasting depth (see page 32)

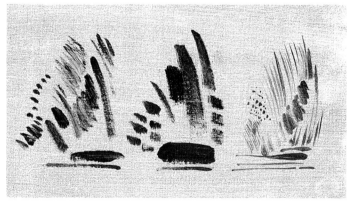

Marks made using different brushes: left to right, filbert bristle, flat hog-hair bristle and sable

TOWARDS THE GATEWAY (detail)
Demonstrating the technique of *alla prima*, this painting is shown in full on page 70

USING A LIMITED PALETTE

In this picture the colours have been kept to a minimum to allow you to concentrate on distributing the forms using mostly tone. When you come to work with a fuller range of colours you will find it possible to manipulate them to make them advance or recede. Here, by limiting the choice of colours, you are forced to use light and dark passages to draw the eye towards a focal point. The ground colour is a light olive green.

COLOURS
- **Yellows** – cadmium yellow and raw sienna
- **Red** – alizarin crimson
- **Green** – viridian and olive green
- **Other colours** – titanium white

BRUSHES
- Hog-hair sizes 2 and 4
- Sable size 3

Stage One
Select your subject and viewpoint
- I painted this with the sun more or less directly in front of me at about 10 am. This is called 'contre jour' ('against the day', which translates as 'against the light') and it helps suppress the colours of the figures, buildings and gondolas, keeping them within a range of warm greys. On such a bright day, wearing a wide-brimmed hat will help you cut out the unpleasant glare while you concentrate. You can arrive at warm greys with various combinations of colours, such as burnt umber, cobalt blue and white. Here viridian and alizarin crimson are blended with white to give a hint of extra warmth.

Stage Two
Observing aerial perspective
- Imagine viewing a distant landscape of hills with the sun high up in front of you. The hills in the foreground on either side of you will appear to be green, but as your eye progresses back to the middle and far distance the colour will change from mid-blue to a paler blue. This is known as aerial perspective. You can see this type of recession here in close-up with the foreground pigeons and figures being stronger in blue-grey tones than those in the middle of the picture and the paler blue-greys of the church and islands.

Stage Three
Compositional layout
- The figures and birds are arranged to help draw the eye towards the highest key point as well as adjusting the tones to suggest recession. The sparkling water is seen behind the gondolas, broken up by the posts which anchor them. The figures are mostly indicated by a suggestion of form and outline, with occasional definition suggested by highlighted hair. Where the pigeons cluster round the grainseller their form is only hinted at, but as they break away from the mass their individual shapes become apparent and they are used to create the accents that help lead the eye through the gaps between the more distant figures.

On certain hot days, when looking into the sun, the sky will appear more yellow or pale green than blue. The ground colour here (olive green) is very near the correct tone and hue and offers a contrast to the higher key passages of water (cadmium

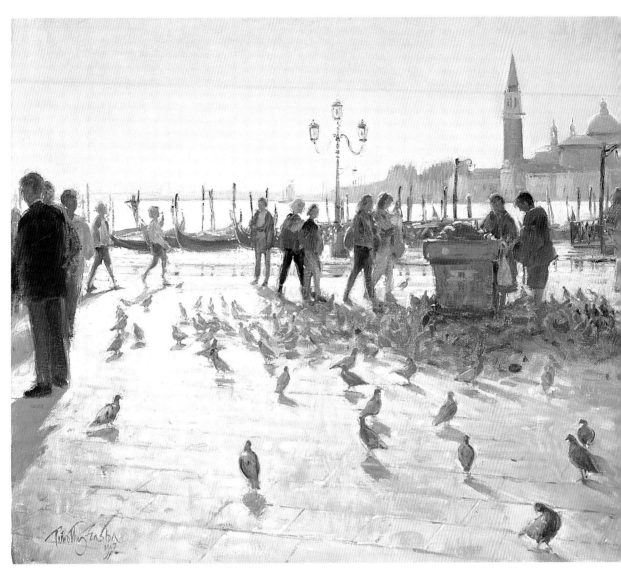

GRAINSELLER, VENICE 30.5 x 35.5 cm (12 x 14 in.)

yellow, raw sienna and white). The pinky-grey paving slabs add warmth to the composition and hint at the strongest colour, which is accentuated by the red jacket on the figure nearest to the most intense light passages.

Landscapes

Painting in your studio from small studies made outside can give you more control, particularly if you wish to add detail, but this might be at the expense of spontaneity. Working directly outside from the subject should give you freshness and simplicity. A combination of both methods may be ideal as the one will inform the other.

HOT AND COLD LANDSCAPES

It is generally thought that shades of yellow and red are warm while those at the blue end of the spectrum are cold. This is too simple a judgement, for the quality of the colour can be changed by its context, the colour it is placed against and, in the case of blue, the colour it is mixed with. We associate earth colours with hot climates, and white and blue with images of icy landscapes, and these associations prejudice our impression of colour. A lush green landscape in early summer could appear cool, and the introduction of fiery red poppies or yellow cornfields will shift the emphasis towards warmer colours. Below are examples of each extreme. These have been selected to show contrast with the warm or cool parts of other areas within each of the paintings.

This painting was produced on several very hot days in the south of France. If you isolate the top one-third of the picture, with the pale blue sky, white cliffs and blue-green hills, it does not appear to be particularly hot. It is the lavender fields, with the red earth between the rows and the foreground pink hedgerow bush, that create the feeling of warmth.

LAVENDER FIELDS, MONTCLUS 51 x 61 cm (20 x 24 in.)

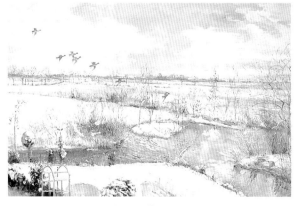

FLIGHT DOWN 40.6 x 61 cm (16 x 24 in.)

The colour of blue used here for the shadows, iced water and pale sky is what you would expect for a cold snow-filled landscape. However, there is a hint of pink in many of the white areas of snow, cloud and ice and a comparatively strong red for the bushes along the moat edge; this helps inject the effect of sunshine and warmth into the overall impression.

PERSPECTIVE IN LANDSCAPE

Opportunities for single-point perspective do not often present themselves. Exceptions would be a straight avenue of trees, a fenced track or road with posts or pylons on either side or, as in this example, rows of flowers or bushes, leading to a focal point. In each case, you need to position yourself to see 'down the line'.

WATCHING FROM THE WALL, MONTCLUS 46 x 61 cm (18 x 24 in.)

Distance and Aerial Perspective
Trees used to create emphatic marks of pattern and scale in a painted landscape can help to lead the eye and create a sense of distance. However, most importantly, it is the modulations of colour and the changing perception of form created by the atmosphere over distant hills and woods which help to create recession.

Centre of Interest
A strong focal point is a necessity in a landscape painting, and perspective is one way to guide the eye towards it. A dramatic contrast, such as a warm colour against cool or light against dark, will also help focus attention. A contrast of scale, a large object against a small one, or a succession of large fields progressively getting smaller, can all help guide the viewer to a carefully chosen area of interest.

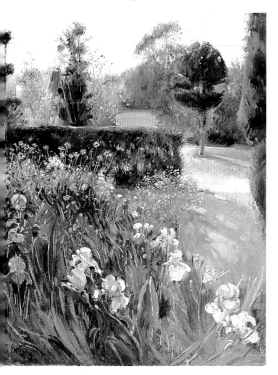

IN THE GARDEN, JUNE 35.5 x 30.5 cm (14 x 12 in.)

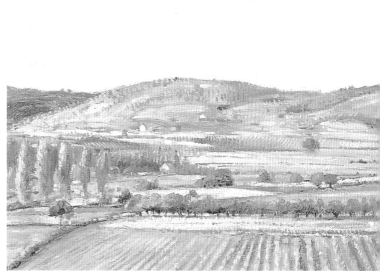

WATCHING FROM THE WALL (detail)

EXERCISE – CONTRAST AND COLOUR IN THE LANDSCAPE

Having looked at one way of making a painting from just a few colours, let us examine another 'contre jour' painting using a more extended range. In the following step-by-step exercise, it was the intense sparkle of the irises in the very early light of a June morning which made me choose this view.

The intensity of this picture is aided by the surrounding rich greens, so it was important first to establish their tones. I frequently mix my own greens, but when working outside in strong light I find using one of the three prepared greens can save time and give a richer effect. If you are confronted with a strong range of colours in your foreground, try to resist the temptation to put these down until you have all your lower-key colours sorted out.

COLOURS
- **Yellow** – cadmium yellow and raw sienna
- **Red** – alizarin crimson and burnt sienna
- **Blue** – cerulean blue and cobalt blue
- **Green** – olive green and sap green
- **Other colour** – umber

BRUSHES
- Hog-hair filberts sizes 2, 3 and 4
- Sable sizes 2

Stage One

1 The basic features of this landscape were set out using thinned-down umber paint. Loose lines delineate the rows of irises which converge in a vanishing point behind the small barn on the right. The trees and cottages were set high in the composition because the flower field would ultimately become the most prominent feature. The back landscape was washed in with monochrome paint to give an idea of tonal mass.

2 More colour was now introduced with the wide bands of plants. No attempt at any sort of detailing was made, but three curving lines of dots in yellow and cream were indicated to lead the eye across the field. The sky was then added to give shape to the trees at the back.

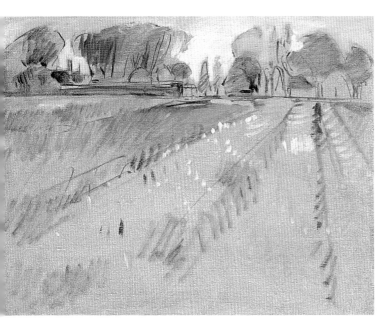

Here the barn features in the space where the vanishing point would become a centre of interest in the distance

Stage Two

1 The dotted curves were strengthened with brushed-in leaves (green and umbers) to continue the overlaid directional sweeps across the parallel rows of irises. Greens and umbers were worked into the back landscape to establish the layers of hedges and trees and the outer edges of these were painted into the sky to blur the outlines. Further areas of blues and greys were loosely indicated to keep up a tonal balance between the middle and far distance.

2 The soil trenches with their cast shadows were established between the rows in preparation for the nearer flowers. This was done before attempting the yellow flowers, which are the highest key colour next to the pale blue sky. The foreground flowers were dabbed in with no attempt at detail.

Stage Three

1 The final session was spent working around the picture making small adjustments usings dabs and lines of paint to give balance, emphasis and shape to some of the flowers.

2 The painting was started at 6:30 on three successive mornings and each session was completed by about 9:30. Sunrise was just out of this view to the left and the highlighted areas were established with the sun directly in front. The trees and flowers are seen against the light, which helps to keep them massed, with the highlights confined to the upper and outer edges.

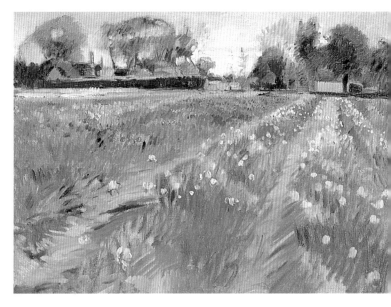

The complementary colour scheme with vivid yellow and purplish blues gives the painting a warm atmosphere

TOWARDS THE WHITE BARN 30.5 x 40.6 cm (12 x 16 in.)

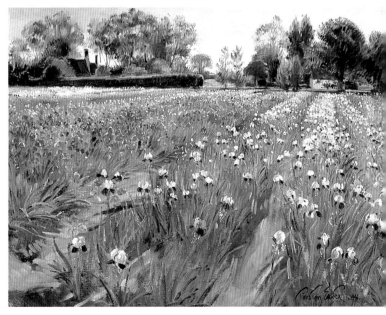

Animated linear brushstrokes in the foreground contrast with the softer, more blended passages in the distance

SEASONAL COLOUR

When new growth emerges after winter or the leaves turn colour dramatically for a few weeks during the autumn, there are opportunities to experience unusual qualities within a familiar landscape. Trees undergoing such transformations may present rich colours with many highlights in strong sunlight and these require a controlling influence so as to impose some order.

Autumn

The subject which influenced my choice of view here was the chestnut tree with its enormous girth that was part of an avenue perhaps five hundred years old. In the shadow is a sculpture of Diana the huntress. The pathway gives an immediate focus to this area of interest, but I have used the cast shadow to soften the effect at the front of the canvas.

The skeletal forms of the great trunk and branches were laid in first with a size 2 hog-hair filbert brush. The leaves were blocked in and then a quantity of multi-coloured leaves were worked into the wet paint with a finer sable brush; the same method was applied to the tree on the left. The sky was broadly set down while the trees were being established.

A simpler treatment was given to the holly tree behind the sculpture, which is silhouetted against the brightly lit, massed trees in the park beyond. A few leaves from the chestnut tree were worked over the holly.

The path and the grass, like the sky, were partly blocked in during the early stages with a size 4 filbert. The paint had little additional medium added. Some of the autumnal colour is reflected within the shadows. Finally, touches of autumn leaves, light and dark, were dabbed in the foreground.

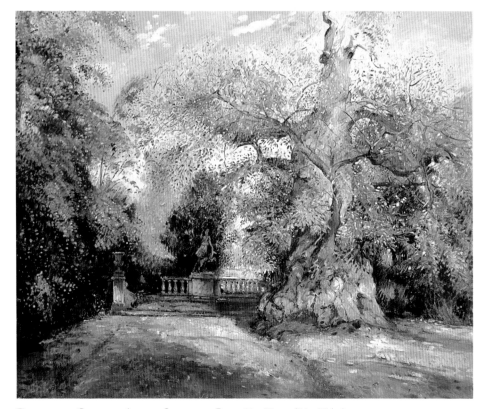

DIANA IN THE CHESTNUT AVENUE, SHRUBLAND PARK 61 x 71 cm (24 x 28 in.)

Winter

There is always something exciting about waking up to see a familiar view transformed and simplified by snow. I worked quickly on this landscape, as I knew it would change drastically in two or three days. I like to work on three canvases at different times of the day and hope that conditions will stay similar enough for me to carry on the next day – usually my luck holds. Most of my paintings are done looking out from my home, so if I miss out one year I am able to complete the painting the following year. This is the one time of year that I find painting directly out of doors most difficult, not because I cannot put up with the low temperatures, but because the oil paint becomes stiff after half an hour in the near-freezing conditions. This means that any studies made outside have to be small-scale and quick.

Just as certain areas in the previous picture were treated broadly to contrast with other more detailed parts, the winter scene below was painted in the same way. The geese on the left emerge half-defined from the shadows, while the three on the right are more fully realised.

Within this relatively restricted palette I searched out many of the half-tones in the strong blue shadows. These are given more impact by being contrasted against pinks and yellows in the highlighted areas of snow. You can translate these into paint with various marks and accents but keep the tones lowered initially. The contrast of dark tree trunks against the snow will also give you markers to other areas which may have much of their familiar detail obscured.

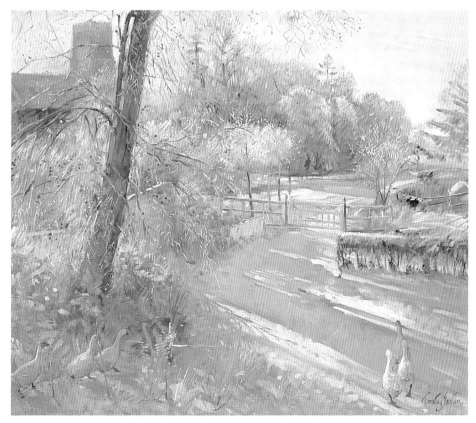

HOAR-FROST MORNING 40.6 x 51 cm (16 x 20 in.)

FRAMING THE LANDSCAPE

Before the idea of painting the landscape in its own right became popular in the seventeenth century, many artists used scenes glimpsed through a window or between columns to give a restricted view. It can be a very tantalizing device which tempts you to look more closely.

For this painting I wished to create a frame to complement the formality of the garden and suggest a distinctive location with Moorish overtones. A tall tree on the left and a wall to the right together with the dark side of the garden tower restrict the breadth of view.

The perspective of the lines of clipped hedges terminating in the zone of vertical trees establishes a link between two horizontal bands of blue in the wisteria-supported pergola and the distant range of mountains. This creates a 'box' (marked by the dotted lines in the diagram) which helps to hold the focus in the centre of the composition.

THE GENERALIFE GARDENS, EL ALHAMBRA 35.5 x 30.2 cm (14 x 12 in.)

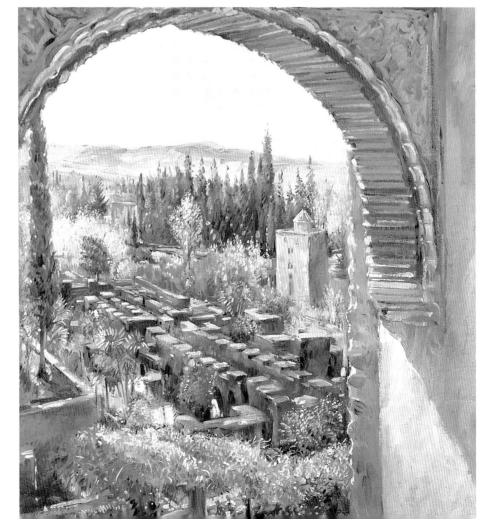

BUILDINGS IN THE LANDSCAPE

Buildings, or parts of buildings, can make interesting shapes, which present a firm structure to set against the sky and land. In the same way that trees offer vertical markers to break up horizontal hedge and field lines, so sections of buildings can offer intriguing geometric possibilities.

The study shown below was painted on the spot in old Provence with the intention of making it into a larger studio picture. It was done in a very restricted area, with walls behind and to the left, and so needed initially to be small. Scumbled paint was used in the upper shaded areas and this helps to give a softening effect to the outer shadowed passages.

The geometry is devised so that the strong verticals are diagonally cut across with softening shadows, which enhance

the surface texture of the wall. In this restricted site, the sun only illuminated the building for an hour and a half and disappeared at lunch time. The long thin shadow of the post sticking out of the wall below the top left window-opening acted as a sundial, reminding me how long I had to work on the studies each day.

The house door, with its three magical marks above, was never unlocked during the week I painted here. The inhabited part of the house stood on the edge of a cliff. The wall to the left is only a façade and you can glimpse the sky through the upper window. The relationship of the two blues used in the sky and door emphasizes this conundrum. It is the parallel shadow-lines that help link them together diagonally.

MIDDAY GNOMON 35.5 x 30.2 cm (14 x 12 in.)

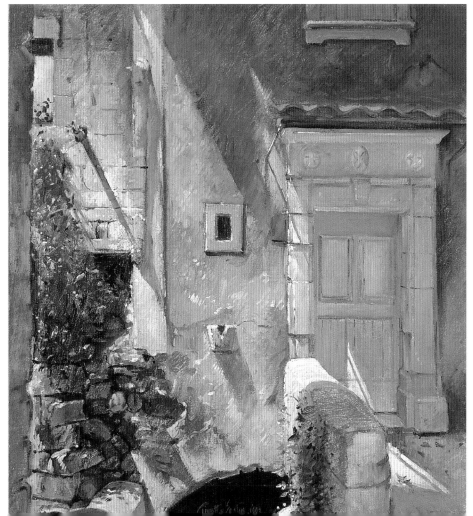

Buildings in a rural context can be used with only a glimpse of the landscape. This makes you want to know more about their environment. The example below also shows different ways of using dry paint, glazing and scumbling to enrich the surface textures.

The diagonal shafts of light illuminate the textures of decaying wood, rusty metal, brick and slate. The colour range was kept muted to emphasize these forms. The decayed wooden planks were first laid down and after a few days were textured by overlaying paint using a dry brush technique to emphasize the grain. Glazes in greens and yellows were later laid over to give a heightened effect of filtered sunlight (see detail on page 21).

The long wall of the bullock yard is buttressed on the left by a redundant barn and this L-shape is picked out again in the missing plank of the barn and the open doorway seen through the window space. The strength of geometry formed the basis for this unusually long composition. The church in the middle-distance offers the same shape, but reversed, to provide an enclosed edge for the composition on the right-hand side. The lack of foreground also brings the viewer closer to the wall.

SCAVENGERS 46 x 127 cm (18 x 50 in.)

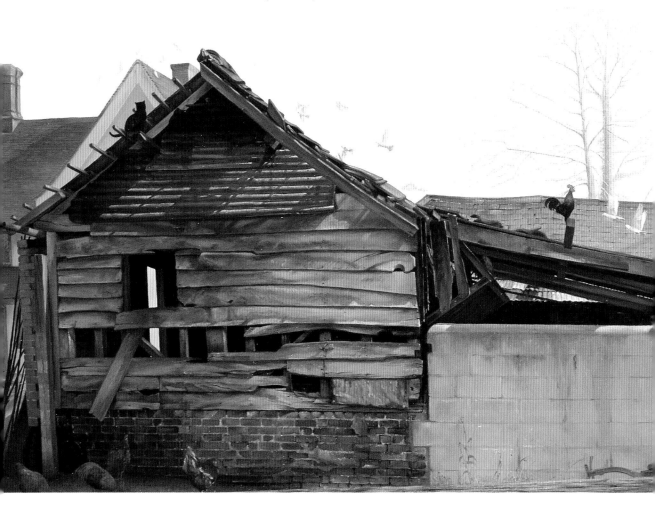

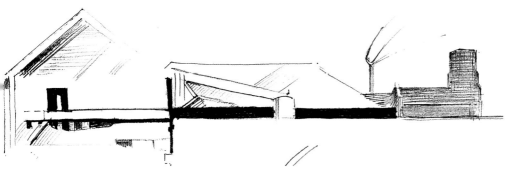

Diagram showing the essential linear structure of dark bands contrasting with highlit walls and window. This geometry gives a tension to the unusually long dimension of this composition

TIP

Drybrushing and glazing need a lot of control and are more suited to paintings made in studios such as this one using a number of outside studies for reference.

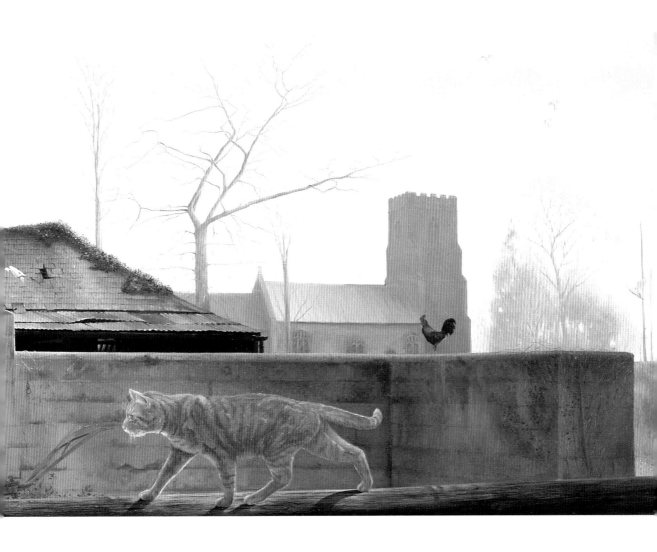

Demonstration

Working alla prima

There is something very satisfying about starting and completing a painting in one session – this way of working is known as *alla prima*. This can be done by selecting a simple subject that can be quickly executed. It requires a spontaneous response using accurate observation with minimal drawing. With a larger canvas, which takes three or four sessions, it can be beneficial to use the experience gained through hours of observation to make a smaller, simpler study. This can be stimulated when a sudden change in light reveals a different aspect of a subject that has become familiar. The painting here was done in this way, after several days working on a larger painting.

COLOURS
- **Red** – alizarin crimson
- **Yellow** – yellow ochre and raw sienna
- **Blue** – cobalt blue
- **Greens** – viridian and olive green
- **Other colours** – titanium white

BRUSHES
- Hog-hair filbert sizes 2, 3 and 4
- Sable sizes 2 and 3

Method
1 The painted lines indicating the bank, the approximate position of trees, the porch and the rhythm of the clumps of background trees were quickly established to get the correct areas of sky and water. Because of the need to get colours down quickly in case the smoke dispersed, I did this next tending not to put monochrome tones down first.

2 The close-toned warm greys and purple-blues used for the church, trees and hedge were laid in with a size 1 and

Delicate lines of varying colour made with a sable brush were added last of all to suggest small, silhouetted branches

Using hog-hair and sable brushes the reflections were worked wet-in-wet

size 3 filbert brush, as was the main mass of the curved bank. The suggestion of blue smoke drifting almost vertically across this area was worked in, partly blending it on the lower side.

3 Sky and water, with touches of crimson and yellow, give a warmer contrast to the first stage. The paint was more fluid for these areas, and reflection markers

Dry blue-grey paint was worked over the background to give an impression of drifting smoke

SMOKEDRIFT IN WINTER 20.3 x 30.5 cm (8 x 12 in.)

were worked into the wet paint. Blending between some background trees and sky gave a sense of diffusion.

The darker tree trunks and their reflections painted in warm greys were also worked into the wet paint and blended near the outer edges to keep the eye focused on the central zone.

4 The darker accents of lower tree trunks and bushes are emphasized while laying in the patches of grass lit between the cast shadow. Many other smaller accents are worked into the wet paint along the banks and further field. All this was carried out with hog-hair brushes.

Using a size 2 sable, the highlights to chairs, table and bush and along some branches were the last details added.

Skies

When you are deciding how much sky to include in your landscape you may be strongly influenced by the nature of the scene you are painting. When confronted by a towering cliff-face or mountains, the point of interest may be in the rock formation, so the sky may occupy a relatively small part of your composition. Conversely, a flat landscape, traditionally the preserve of Dutch and East Anglian painters, may suggest that the sky should be the dominant feature of interest.

TIP

Clouds rarely stay still, but once you have a range of colours mixed up you can select the moments when you see formations that seem to reflect the mood of the day and the way the light is dispersed over the landscape. The perspective created by receding clouds may also allow you to suggest a sense of movement that complements the land below.

SKY TYPES

• Cumulus clouds, those large bands of puffy white clouds, are perhaps best formed using impasto paint. Where they are lit from one side, they will have their main highlights. On the darker side there will be lighter half-tones which may reflect the colours of the land or water below (see pages 38–9 and 46).

• Cirrus clouds are less likely to reflect land colours because these are the thin feathery patterns seen highest in a clear summer sky. They can be painted with a dry brush technique, allowing some of the blue sky beneath to show through.

• The darkest cumulo-nimbus clouds are usually set lower, towards the horizon, and are a portent of rain. Like the cumulus types, they will have half-tones in the darkest colours which will reflect colour from the sky above and the land below.

The light of a sky influences the mood of your landscape painting and should not be treated as a separate entity. Colour from the land should be reflected in the cloud formations, and sky colour filtered into the land below; this will help prevent a disjointed painting.

Cumulo-nimbus Cumulus Cirrus

SEASONAL SKIES

Still Summer Sky

The painting here was part of a series painted in northern Denmark during an exceptionally hot summer. There was no wind and the cumulus cloud formation remained unchanged for several hours. The cloud shadowed some sections of the land in the middle distance, offering a contrast with the highlighted dune on the horizon which is one of the largest in Europe. The shadow of the chimney on the partly lit thatch echoes the direction of a light path seen in a gap between two buildings. This directs the eye beyond the roof, which occupies nearly half the painting, to the dabs of broken colour in the middle distance.

The sky was painted using a combination of cobalt blue, yellow ochre, cadmium yellow and white. The mixed colours were graduated, introducing more of the yellows towards the right side and the horizon. The paint was applied without much medium and by the evening was sufficiently dry to blend lightly with a sable brush without removing all the contrasting patches of colour. Mostly I would not blend the sky paint as the texture of the brushmarks can greatly add to a sense of movement. Blending was used here to create the opposite effect of complete stillness.

Sunset with Clouds

In this detail from a larger painting, the sky, which occupies one-third of the canvas, leads the eye down to the distant trees on the left. The brushmarks are structured to emphasize this recession. (A path across the field below is going in the same direction to help create a focal point on the horizon.) The warm greys imply an overcast sky, but here they are combined with the yellows and pinks caused by a setting sun on a hot late-summer evening.

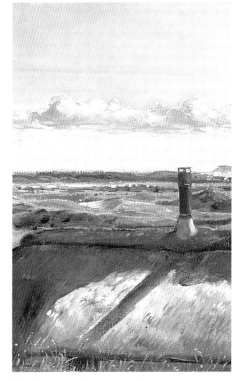

THE STATIONARY CLOUD (detail)

BLACKBERRY HARVEST (detail)

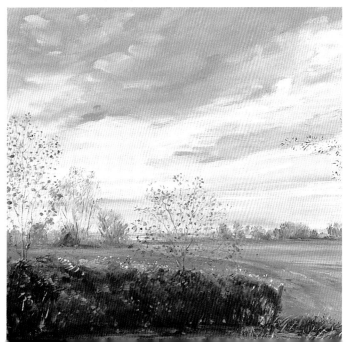

DISTANCE AND FOREGROUND

The vantage point of a hill, which looks out over many miles of countryside, will provide you with an opportunity to capture the effects of aerial perspective.

The atmosphere will affect the colour and tone of the distant landscape and this will be particularly noticeable when the day is hazy.

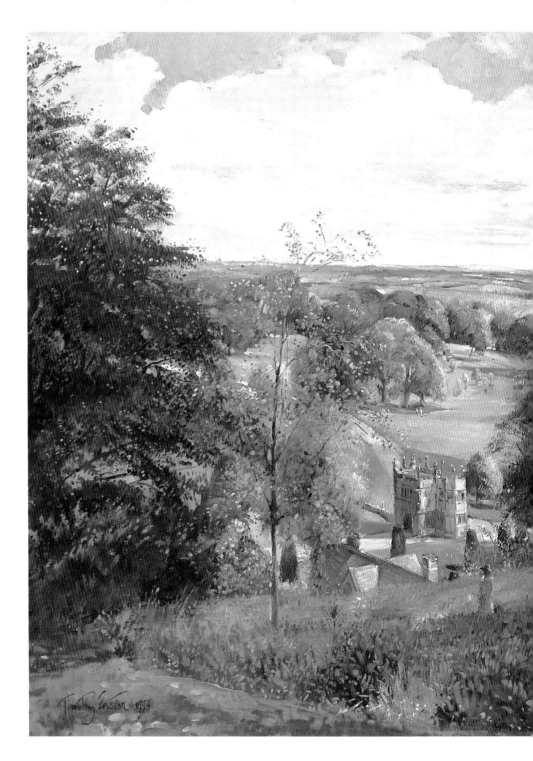

LIGHT AND SHADE

In the painting below, which has no obvious linear perspective, I used modulations of colour and tonal contrast to create a sense of distance. The bands of layered clouds become narrower towards the horizon and, where the sun breaks through, the gaps accentuate particular areas of the landscape. These highlights and shadows constantly shift, but they do form a pattern that allows you to select which areas to emphasize in order to give the right impression of distance. At the bottom right there is a shadowed area which is caused by bushes rather than clouds, but painting the foreground as if it is in cloud shadow can be a useful device for suppressing the nearer detail and directing the eye towards the middle distance. This method is known as 'chiaroscuro'.

COMPOSITION STRUCTURE

There are other structural devices used here, which allow the eye to travel as well as focusing it within the central area. The strongly lit gatehouse stands at the axis of a path between a great house at Lanhydrock (hidden from view on the left) and the landscaped park. The trees to the right of, and above, the architectural features carry the eye across the top of these to the middle distance. The tall trees on the extreme left and right control the outward movement. The swathe of bluebells carpeting the foreground is broadly painted from shadow into full light and reflects the horizontal blue tones of the far distant hills. These features help to create a 'box' in which the sweep of the trees diagonally links the foreground to the horizon.

Across the Park, Lanhydrock 61 x 76 cm (24 x 30 in.)

Demonstration

Linking sky and land

TIP

With a bright luminous sky, half-tones may be less easy to see and you may have to squint through your eyelashes to cut down some of the glare to perceive them. Alternatively, use your Claude Glass to help you sort out the mid-tones.

This painting features a large sky. There is a mirror-form between the cloud layers and the curving ditch, with the stubble and ploughed fields on either side. This has the effect of bringing the eye towards the horizon, detailing trees with glimpses of fields beyond. I captured an impression of the sky by using observations gathered over several hours. The darker clouds blowing in from the left break up the sky area into contrasting light and dark colours as well as a range of half-tones.

You will need to make frequent adjustments to the tonal balance between sky and land. It may be necessary to darken a bright sky to enable a range of half-tones to be established. You may then need to adjust the area of land by lightening it to complement the sky. This becomes evident when photographing the same scene – if you were to adjust your exposure to the sky, the land area would look rather dark while if you correctly adjusted the exposure to the ground area the sky would appear very pale, with little contrast between the clouds. As a painter, you can make adjustments to these tones to create a balance that works, introducing colours from one to influence the other, creating a real feeling of light.

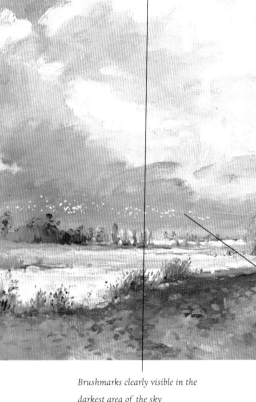

Brushmarks clearly visible in the darkest area of the sky

COLOURS
- **Yellows** – cadmium yellow, yellow ochre and raw sienna
- **Red** – permanent mauve and burnt sienna
- **Blues** – cerulean blue and ultramarine blue
- **Green** – olive green

BRUSHES
- Hog-hair filbert sizes 2, 3 and 4
- Sable sizes 2 and 3

Method

1 It is the interesting formations of the sky which dictate the position of the horizon and this also helps in the decision as to where the curving edge of the field is placed: this curve mirrors the form of the diagonal dark cloud. Both help to direct the eye to the central clump of shadowed trees.

FIRST PLOUGHING, TOWARDS TANNINGTON 30.5 x 46 cm (12 x 18 in.)

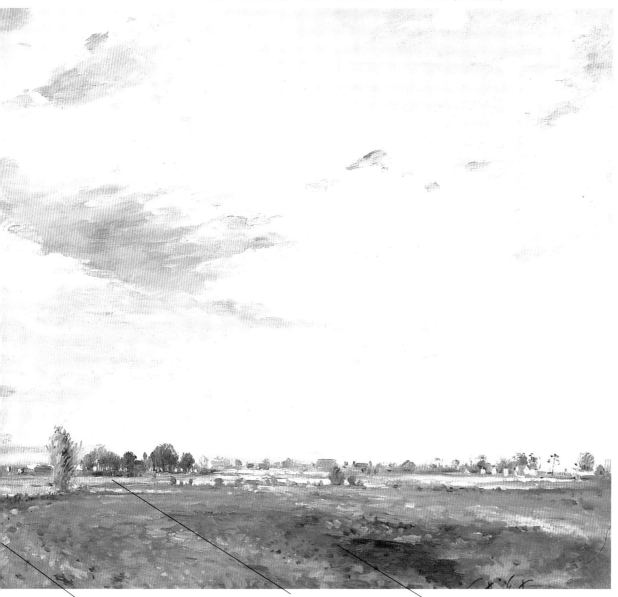

Flock of white birds lends an element of contrast and helps to focus interest on the middle ground

Pale yellow and orange brushmarks contrast with purple tones of distant trees along the horizon line

Foreground kept relatively simple with dabs of colour applied in curves to draw the eye towards the middle ground

2 When setting your main cloud formations down, lay out your landscape below so that you work the two together. Don't make the paint too wet. Using a filbert, build up the gradations of colour and tone and always be receptive to changing your brushmarks to incorporate cloud shades which suddenly present themselves to you. You can blend the edges of colour where required using a sable or a fan blender.

3 The land is made up from flat passages of colour with dabs of broken colour on top – note the areas where sky colour is reflected in the soil and the stubble colour is introduced into the sky.

Water

Many people find water difficult to paint, due to the lack of a support structure such as fixed objects for marking and checking. You are also dealing with a subject which may be in motion or disturbed by wind. Whereas with any still subject you can look, absorb, make judgements and paint your interpretation in rapid succession, moving water requires intense observation; you really need to look for many minutes before turning away to interpret what you feel and remember. The great flexibility of oil paint makes it an ideal medium for making changes by scraping back and re-establishing patterns of paint if you are not happy with your first results.

STILL WATER

Calm water acts as a mirror, reflecting sky and trees, but usually in darker tones. Because water should be painted with constant reference to the sky and not as a separate entity, it will also contain a range of colours that are common to both. Reflections do not usually show the same degree of detail so the mass and edges can be generalized. Note the way floating leaves, positioned on the left-hand reflection in the example below, help to describe the top surface of water.

MOVING WATER

Here the ebb and swell of a tide on the turn in a cove is represented with alternating light and dark dabs of paint organized into rhythmic patterns that suggest the movement of waves. Certain types of movement, like a waterfall, are relatively easy to paint because the continuous stream can appear almost static. With the rhythmic patterns of water flowing around rocks, there is usually a repetition of movement which can be understood after careful observation and translated into paint.

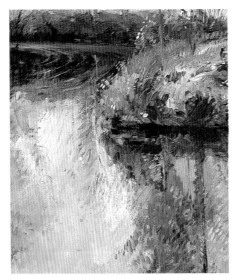

Stubble-Grazers (detail)

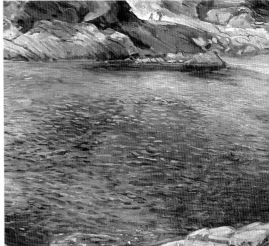

Lansallos Cove (detail)

REFLECTIONS

Your interpretation of reflections will be dictated by the degree of light and movement of water. The sea reflecting the waterfront buildings on page 7 allows a high degree of contrasting colour because of the sunlit walls; this is translated by overlaid squiggles and dabs of alternating colours. A similar method, using a more limited range of colours, was used with *alla prima* on pages 34-5. On fairly still water (see pages 46–7) more direct horizontal curved lines create the reflection of the actual leaf forms above. Much can be suggested rather than specified, and in this section of a painting the outlines of the horses are defined only around their heads. By painting the light tones within the darker shadows you will keep the reflections animated.

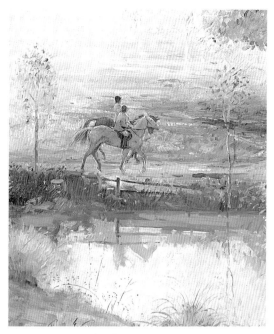

OUT OF THE MIST (detail)

LIGHT ON WATER

Finding a way to translate the sparkle of sunlight on water requires considerable editing of the visual elements in front of you. The sparkle seen through half-closed eyes will help you to isolate the specular effects. You may have to organize and limit the highlights for this to work successfully. In this painting the middle area of concentrated light is broadly worked in half-tones, while the outer sparkle is arranged in patterns to create a diagonal snake across the water. (See also the detail of *Beachwalk* on page 19, which shows a similar effect.)

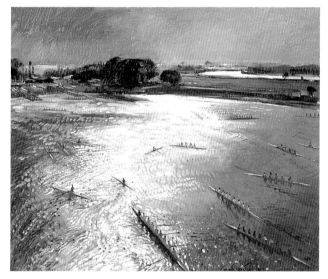

COLLECTING POINT 30.5 x 35.5 cm (12 x 14 in.)

SELECTING YOUR VIEW

Your choice of an area of water to paint, and the position of your horizon are both very important in establishing the mood you wish to convey. With large expanses of sea viewed from a cliff top, you are likely to place the horizon higher up in your composition than in the same view seen from the beach below; at the lower level there will be less distance between horizon and foreshore so you are likely to compensate by showing more sky. Try using a viewfinder to select a part that you think will make an interesting view and move it around to include other features which might help limit the amount you show. The exhilarating panorama of an estuary or an open stretch of sea is very difficult to convey and it may be better to select a portion to suggest a great breadth of water.

In the example opposite I was working around a beach house near Skagen in Denmark for a fortnight. It was difficult to find a satisfactory viewpoint of the great expanse of sea until I restricted it by including some dunes. Without these and the setting sun there was little to offer in the way of a focal point. There are no obvious perspective lines to help, so I animated the brushwork used for the sand to suggest a direction towards the sea. A scene like this with strong horizontal lines is helped by any verticals which break

through to enliven the composition. The distant figures at the sea edge, passing across the sun's reflection, were a useful connection with the focus of the excited boys as they started to run down to the beach. By setting the horizon high and limiting the amount of sky shown, I was able to create a greater area of water. The section where the sun shone was initially painted on this canvas using the information from a smaller study, made in situ, that showed a more solid mass of highlights. Back in the studio, working on a different scale, I found this patch of highlighting too distracting, so when it was quite dry I scumbled some paint over parts of it to knock back some sections (see scumbling detail on page 19). The broad areas of the sea to the left and right have a less broken texture than the fractured paint around the sun's reflection. Some areas of the breaking waves and their highlights are emphasized to create accents that direct the eye back to the focal point.

TIP

Although a panoramic view may invite you to select a long rectangular canvas, a square-shaped panel can make the outer edges of the composition seem less intrusive and create a sense of circular balance without sacrificing the breadth of view.

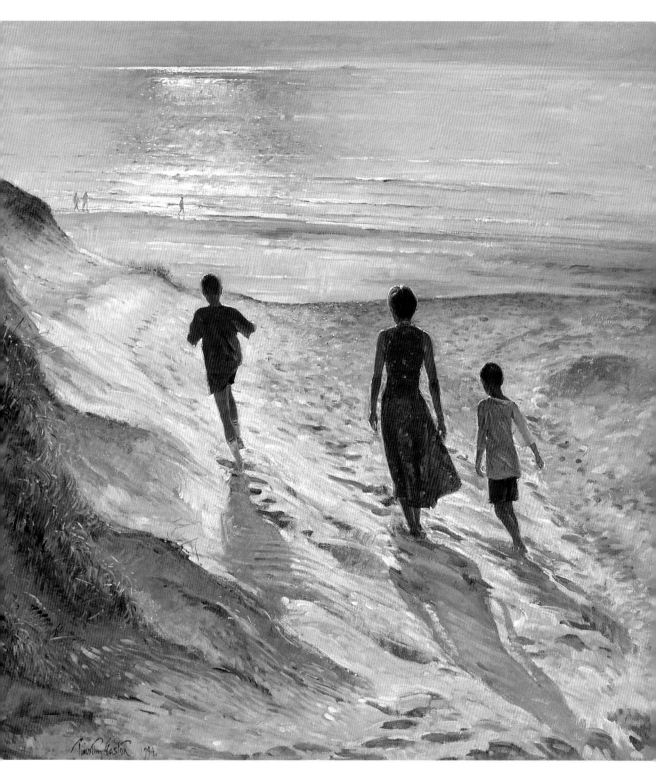

BEACHWALK 76 x 71 cm (30 x 28 in.)

STILL WATER AND REFLECTIONS

A calm pond is probably less confusing to view and understand than the three-dimensional qualities of a moving sea, but capturing the depth and transparency as well as the reflected surface can present a challenge. Painting the sky and clouds and their reflections in darker tones with the same brushmarks might not make for a very interesting painting. Introducing a disturbance will remind the viewer of the water's quality and can also be used to direct the eye around the composition. You may logically feel all your brushmarks should be applied horizontally, but these combined with looser vertical marks will enliven the surface.

Adding thin glazes of transparent colour over a solid broken base should give a very fluid look to the water, but most of the desired effects can be achieved with more direct brushmarks. For variety try combining the two methods.

The painting below was as large as I could fit on my easel box when working outside. It was painted over three days, during the last year that stubble was allowed to be burnt in the UK. The flames and smoke can be glimpsed on the left above the hedge.

Method

1 After setting out the composition, I established all the darker areas, including the reflections of the trees. Against these it was possible to judge the mid-tones using the darker blues.

2 A gentle breeze was blowing across the water, and this allowed me to break up the foreground paint to give some contrast to the still passages under the left-hand bush and around the little island (see detail on page 42). I was able to use the patterns created by the wind to move the eye around the reflections in the bottom right corner.

3 The late afternoon sun was shining low across the water from the left, and where it filtered through the bushes it broke up the dark reflected shadow – notice how the light does not show on the blue passages. Apart from the first thin washes, most of the application was done with dry paint, working the colours up from dark to light.

STUBBLE-GRAZERS 76 x 101.5 cm (30 x 40 in.)

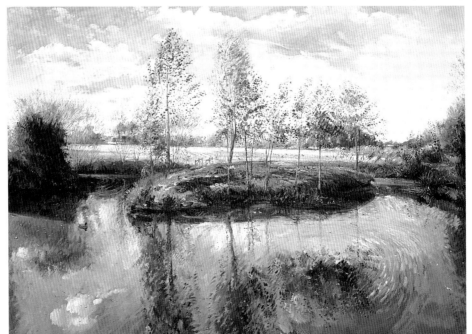

This example shows another instance of relatively still water, disturbed only in part by wildfowl. The bridlepath is constantly used by riders and I painted this from my studio window. It was the largest painting of a number of studies made in these misty conditions.

Method

1 I began by concentrating on the water and reflections, using the passing hunt as a vertical anchor because at first the early morning mist was just beginning to clear and the sky was not visible. The reflection of the sun trying to break through the cloud indicates the time of year and conditions of reduced light.

2 The picture was constructed using several smaller studies and then completed with direct observation of the water and foliage. The central area of water is very simply stated with the graduated change of colours from pale yellow-greys around the reflection of the sun to blue-greys towards the extremities.

3 The rippling effect of rings near the ducks helps to break up the outer edges and concentrate attention on the focal area of the central riders, their shadows and the sun and foreground plants. The two saplings and their reflections give additional stability, while other outer edges are less fully realized. Scumbled paint was used to establish the foggy effects at the top.

EARLY MORNING RIDERS 51 x 76 cm (20 x 30 in.)

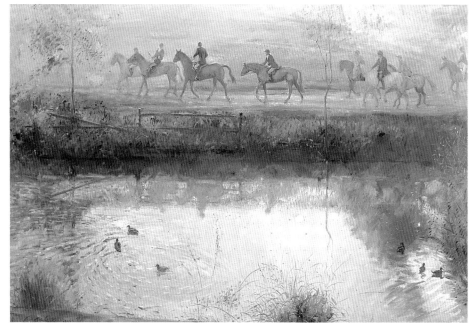

SHADOWS ACROSS WATER

We know that still water will act as a mirror, reflecting the colour of the sky or objects along the bank such as trees and buildings. When a shadow is cast across water reflections, it can make a positive contribution by providing a contrast with the brighter areas of the reflections and creating the illusion of another dimension. Shadows, by their strength and length, also help to evoke the time of day. Two contrasting pictures are illustrated and discussed here.

BELOW THE HEDGE 61 x 61 cm (24 x 24 in.)

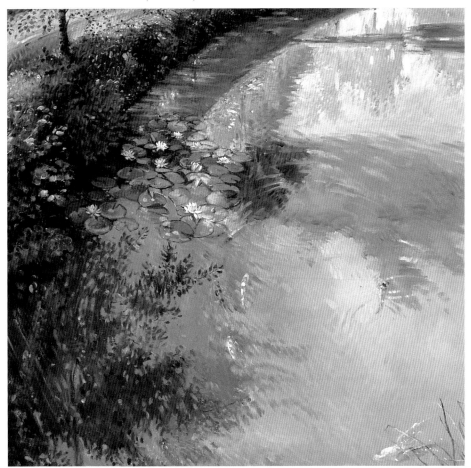

This example shows a painting completed over four mornings.

• A high vantage-point is taken so the picture consists principally of water, with the effects of strong sunlight and the resulting shadows of the hedge and the trees.

• Notice how the coloured reflections of the two saplings alter as the shadows of each and the hedge pass across them. Stability is given to the water mass by these shadows and the lily pads.

• The directional brushmarks of the leaf reflections and the position of the fish give a feeling of circularity to the lower half; this is also helped by a square-shaped canvas.

This second example of shadows on water is a relatively quick study showing geese on a pond in autumn.

• The paint was applied thinly and loosely over much of this painting. There are probably more vertical strokes for the water than there are horizontal brushmarks.

• Shadows, like reflections on still water, can often work best when kept simple. For these long, late-afternoon tree shadows, a wash of warm umbers and mixed greens was used with occasional brushmarks of blue-grey dabbed into it. Highlights of light grey were applied next to break up the edges where the sky was reflected.

TIP

For slanting shadows, such as those seen here, brush them in the direction they appear and then work your vertical marks into and between them to give the feel of the reflected foliage.

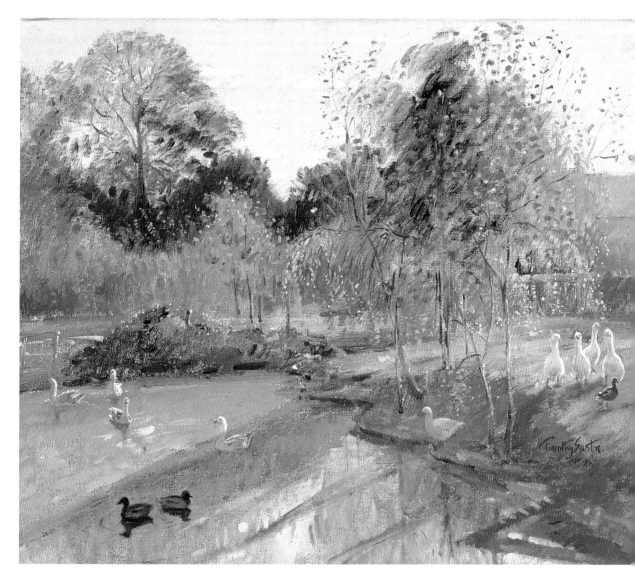

AUTUMN BEECH AND GOOSEPOND 20.3 x 30.5 cm (8 x 12 in.)

FOREGROUND, MIDDLE DISTANCE AND FAR DISTANCE

When water is to occupy the major part of a composition, you must decide which part you wish to emphasize and how you will suppress some areas in order to direct the eye to the key passages. It may be that the foreground will offer the most interest, perhaps with waves breaking on a beach or, as in the example on this page, a gentle swell with rippled patterns along the length of the boat. If you choose to enlarge an expanse of water, you will benefit by elevating yourself or using visual tricks such as a high horizon line in your composition. If the background disappears altogether as in the painting on the facing page, you will need some strong anchor points. From this kind of vantage point with very still water, the reflected images can be interesting to paint, but may disorientate the viewer who will want to turn the painting the other way up.

- In this painting, the main point of interest was the fixing of the blades by a crew at Henley just before the start of a race. The foreground rower and his blade create a strong diagonal to counterbalance the opposing angle of the boat; this device holds the attention to the intersection where the crew is confined. The rower's gaze is directed toward the point where the blade enters the water.

- The circular ripples and the foreground swell also help keep the main concentration of view within the lower two-thirds of the composition where all the preparations are taking place.

- The treatment of the middle and far distance is broader, and this creates recession. This is underlined by excluding most of the buildings and setting the edge of the far bank high up in the picture, thus making the river look wider.

- There is a marked difference of tone and colour between the foreground and the far bank. The upper half of the painting shows the water graded from alternating pale yellow and pale green brushstrokes, to some darker shadows in warmer greys around the margins. The foreground water is reflecting more of the blue sky.

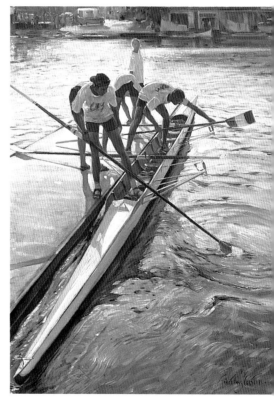

FULL LENGTH 40.6 x 30.5 cm (16 x 12 in.)

The focus of interest for this painting was the results of a race being hoisted by the scorers with their light jackets contrasting against the water.

• Due to the restricted angle of the view from the platform, the painting required the positioning of the rowing boat in the upper right portion of the picture to offer a higher point of interest to expand and balance the composition.

• The water is broadly treated and the shadow over the foreground is exaggerated. This creates a strong background colour for the figures and also a contrast to the upper stretch of water in which the two Olympic gold medallists, Stephen Redgrave and Matthew Pinsent, are featured.

• The directional brushmarks of the water form curving lines roughly parallel with the front bar of the standing; guiding the eye to the bow of the receding boat.

HOISTING RESULTS, HENLEY 40.6 x 40.6 (16 x 16 in.)

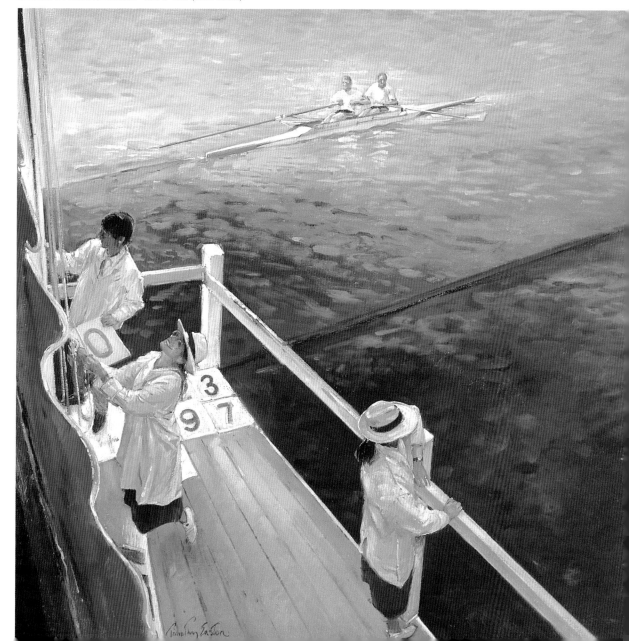

You can now acquire various types of portable halogen lights in the form of a torch or a light on a headband which will aid you when working in the dying light of the day.

EVENING AND NIGHT LIGHTING CONDITIONS NEAR WATER

So often when a magical late evening sky is seen, the dark tone of the land area below makes it difficult to translate this and create a satisfactory tonal balance with paint. The reflection coming off the water during sunset will lighten the lower part of your picture, although you may need some artificial light around your painting to see exactly what you are applying.

Twilight

I painted the picture below on two of those long, warm early summer evenings when the light lingers long after the sun has disappeared from view. When I began there was sufficient light to see what I was mixing and applying, but by 10:30 P.M. I had to complete the picture using my car headlights.

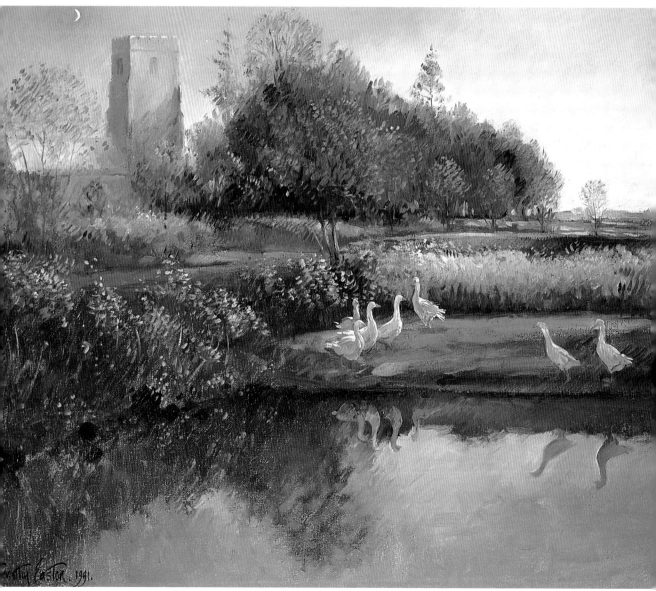

GEESE AND CRESCENT MOON 25.5 x 30.5 cm (10 x 12 in.)

Moonlight and Lamplight

This painting was begun before sunrise on a summer's day in Cornwall. The full moon was not light enough to paint by and I had to use the rear inside light as I sat in the back of a station wagon. The moonlight did, however, illuminate the sloping path to the ferry and the house to the left with a little additional help from a street light. The main focus of illumination was coming from the reflections of street lights in the small town on the other side of Fowey harbour. The vertical bands might have been too obvious without the change of pattern caused by the tide turning.

MOONLIT START 30.5 x 25.5 cm (12 x 10 in.)

TIP

If you would like to attempt this sort of project, try working on a couple of small paintings at the same time. As the daylight comes up, it will reveal certain areas which seemed mysterious earlier on because part of the information was hidden. You could use this higher light level on one of the studies to find out which one works best. From this exercise you could combine the accumulated knowledge in a larger picture in more controlled lighting back in your studio. Both these paintings were afterwards used for larger compositions.

Demonstration

Painting reflections on water

TIP

For areas with large amounts of reflected light whether from sun, moon or electric lights, you may need to simplify and break up the area of sparkle so that the effect is not overdone.

With smooth water, the best effects are often achieved with the most economical brushstrokes. Lay down reflections of trees and buildings with thin mid-tone colours and work lighter and darker passages wet-in-wet to achieve distorted images. Experiment by varying the density of your paint for contrasting colours. The information required for this composition was gathered from several studies, but there are some straightforward methods employed for the application of the water, sky and landscape. If you wanted to include moving figures and boats these would have to be integrated from separate studies.

COLOURS
- **Yellow** – cadmium yellow and raw sienna
- **Red** – cadmium red, alizarin crimson and burnt sienna
- **Blue** – cobalt blue and cerulean blue
- **Greens** – olive green and sap green

BRUSHES
- Hog-hair filberts sizes 2, 3, 4 and 6
- Sable sizes 2 and 3

Method

1 The buildings, church and Garrick's Temple in this water study at Hampton are notable features on this stretch of the Thames. These were first drawn in and blocked with monochrome paint to set up the relationships between them, the river and the reflections.

2 For the middle and far distant water, thin washes of mid-tone colour were worked one into another. Drier pigment from the lighter-tone sky reflections was dragged across to give continuity.

Vertical brushmarks help to terminate most horizontal strokes and offer contrast

3 The sky and reflections of sky were applied next with stiffer paint (the sky was blended later when nearly dry).

4 The colours for the buildings and their reflections were established and were also introduced into the water.

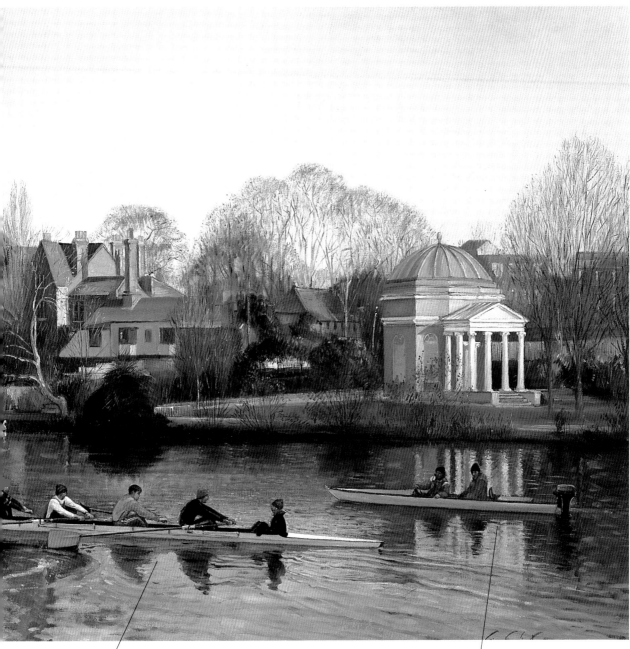

Paint used in sky reflections can have thicker impasto built up to contrast with darker areas

For strong, repetitive patterns you may require a means of breaking them up to restrict too dominant an effect

Dry, vertical brushmarks of sky were overlaid to the left of the church tower into the wet, darker colour of reflected leaves. These not only give some feeling for the form of willow branches, but also act as a buffer to the majority of the horizontal lines expressing ripples. Large areas of highlighted reflections will need to be modified with imagination to create a credible effect.

Flowers

TIP

With big distinctive flowers, like irises and lilies, the outer shapes make them easily identifiable. However, it is worth noting that the space around and between them is equally important. Try making a drawing first to see how you can achieve a satisfactory balance before starting to paint (see page 77). You will then be better informed when you begin to draw-in on your canvas.

When painting a garden or a field of flowers, a decision has to be made whether to isolate and concentrate on the plants as foreground or see them as a mass of colour, with some defining highlights, within a broader landscape. In this chapter, these options are discussed together with ways of approaching flowers in an interior setting.

COLOUR

When painting outside you need to take advantage of the light direction to enhance or suppress the colour. You have more control of this factor indoors. Apart from deciding which colours to put together and whether they should be close in tone, the background colour will make a great difference to the mood. In this painting of anemones, the infiltration of strong sidelighting and the central crimson flowers give life to a selection of colours that could have been quite sober.

ANEMONES IN A BLUE GLASS VASE (detail)

CAPTURING DETAIL

When we think of paintings that detail individual flowers, these are usually carried out in a water-based medium. The characteristics of oil paint perhaps dictate a more textured approach to massed flowers. However, individual plants – such as lilies – make an ideal subject for portraying detail, since their features are both large and distinctive.

COURTYARD LILIES (detail)

MAKING YOUR COLOURS GLOW

The amount of colour that flowers radiate is dependent on the quality of light they receive and the colours they are placed against. You are more likely to achieve a meaningful glow if you place them against a background with a close tone or a contrasting colour. Too much light will illuminate the shape, creating strong shadows that enhance sculptural potential. Seen against the light the colour will be strongly suppressed and it will be the outer shape which is most noticeable, but place them in a corner with a harmonizing colour behind and they will begin to 'sing'.

HONEYSUCKLE AND AUTUMN FLOWERS (detail)

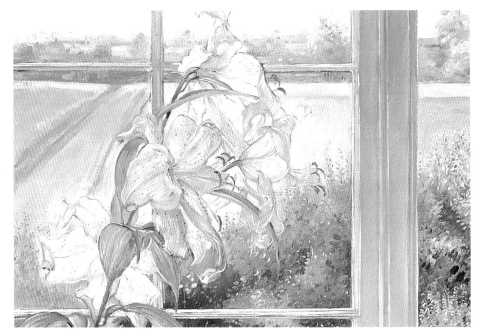

LILY AND WINDOW SEAT (detail)

EXERCISE – PAINTING INDIVIDUAL FLOWERS

Although there is no rule that states that a single flower should not be the focus of study in an oil painting, the result would generally be classified as an illustration. For such botanical studies, water-based paints have been used for many centuries. The more vigorous way in which oil paint may be manipulated may dictate using small groups of flowers that are inter-related. Here I have isolated a few distinctive heads and stems to use for a demonstration study painted over three hours. The colours chosen were deliberately limited so that the concentration is on the overall design and the form of each flower.

Stage One

The shapes of the iris heads were drawn in with a sable brush using thinned olive green on the same coloured background wash. The main colours were blocked in with adjacent dark areas established so that I could have an idea how the relationship of dark and light worked throughout the composition.

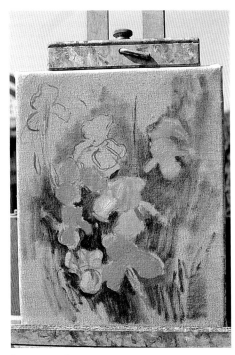

IRISES, stage 1

Stage Two

Further drawing with lean paint gave lighter modulations to each flower head. The tone and colour of most of the background (using little detail) was established at this stage. Note how the colour used for the blue flower is introduced into the pink and yellow irises and the pinks of the foreground flower are used under each of the blue irises.

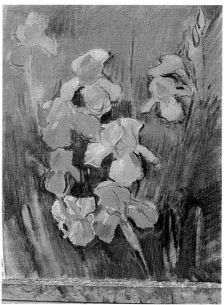

IRISES, stage 2

Stage Three

Sufficient detail was worked into the green leaves, varying the degree of impasto, to suggest the background. The upper areas were kept simpler to help give a sense of recession in the picture plane. Accents were made to give some upward motion: flecks of colour, like the red stems, help to break up the mass of green leaves, and were added to complete the form.

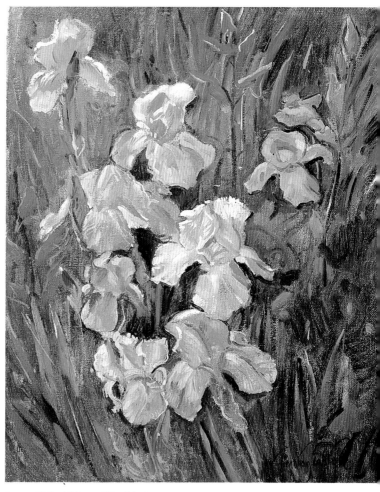

IRISES 25.5 x 20.3 cm (10 x 8 in.)

FLOWERS IN THE FOREGROUND

If you decide to use plants as a foreground feature in a flower bed or field, think about the way you define these in contrast to those which form a backdrop. You need to make a decision about where to place the emphasis, because the eye cannot take in the whole scene with the same degree of clarity. This can be achieved by using variations of paint thickness and also by means of the composition structure.

The focus in the picture below is very definitely on the three groups of low-growing flowers in the foreground. Although the landscape is well lit, the rest of the field is more broadly treated to help keep the attention on the subject at the front. The choice of a high horizon line here also gives the required weight to the area of the flower field. By emphasizing and organizing three groups of iris heads in a triangular formation, the eye is held initially by the foreground flowers. The triangle leads on through the diagonal bands of yellow and mauve to the secondary area of focus – the woman gardening outside her cottage.

With the sun directly ahead, selected parts of the roof are lit while the building and part of the field at the front remain in shadow. By accenting firstly the flowers in the foreground, following through the light mauve and yellow, then highlighting the gardener and the roof-planes that lead down to the grass before the left-hand clump of trees, the eye makes a controlled journey around the composition.

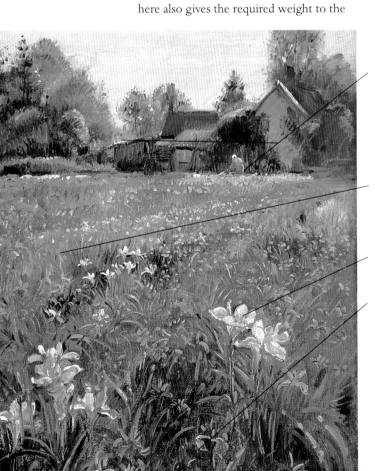

When detail is kept out of the shaded buildings, the eye takes in the figure before it as a prominent marker, and explores the various roof pitches and ridges which lead down toward the base of the left-hand clump of trees, then back on to the field

In the middle zone of the picture the flowers are treated very broadly: note how the blue iris heads have been deliberately displaced across the band of yellow so as to soften the edge and help keep the eye focused on the central axis of the composition

The focus is on the flowers in the foreground so these are delineated more carefully than the rest

By submerging the foreground into shade, a contrasting foil is provided for the two clumps of white flower heads

DWARF IRISES AND COTTAGE 25.5 x 20.3 cm (10 x 8 in.)

This picture shows the same copper container as that seen on pages 18 and 19. Whereas the latter was viewed in the fading evening sunlight, here it is in full sun at midday. Any desire to deal with the lighter passages was suppressed until every part was well established. The white daisies were suggested in mid-tone greys and blues, which still stand out distinctly from the dark green mass of shadowed vegetation. These darker passages in the painting and the shadow below the copper still retain their first thin washes. By comparison, the lighter areas of surrounding path and highlighted flowers worked up in tones have more impasto. Permanent magenta and alizarin crimson were added to the palette to extend the range of the many blue plants.

TIP

Try to see flowers as a group rather than singly and perhaps position yourself, as in this painting, so that the light is before you. This will help you to reduce the individuality of each flower.

FLOWERING COPPER 61 x 46 cm (24 x 18 in.)

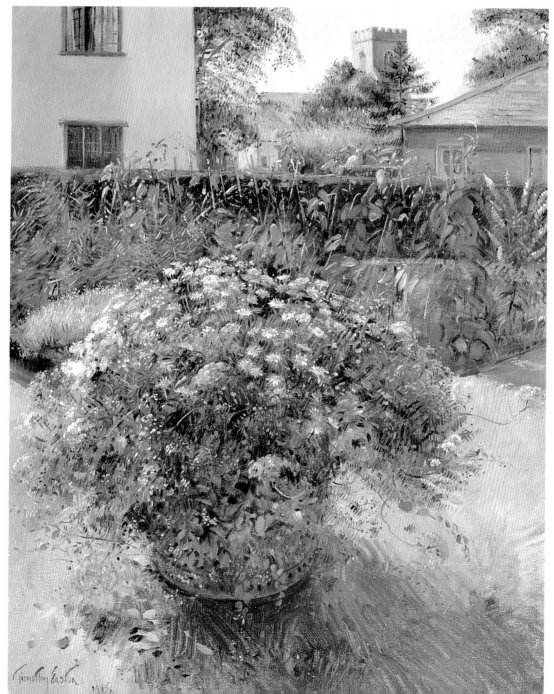

FLOWERS IN THE LANDSCAPE WITH VARIED LIGHT CONDITIONS

When painting an expanse of flowers, remember that the individuality of each plant is enhanced if the sun is shining from the side. When viewed against the light, the flowers will appear darker in tone and more as a mass. When the plants are either side or fully lit, care needs to be taken to avoid a 'spotty' painting. These two contrasting pictures demonstrate a way to overcome this problem.

The picture shown below was painted between eight and eleven on successive hot June mornings with the sun high on the left-hand side. The spikes appeared well lit, and to overcome the possibility of too much individuality with each flower some sections have been blended together and treated broadly. As a contrast, the single heads are painted so that they form groups or lines, giving a sense of direction towards the middle distance of the picture.

(Above) DELPHINIUMS AT WORTHAM 51 x 61 cm (20 x 24 in.) (Opposite) EVENING GLOW 30.5 x 25.5 cm (12 x 10 in.)

The picture shown opposite was worked on in the fading light. By using pale blue-grey and purple for the less well-lit flowers in the foreground against darker greens, the irises glow from the shadows. A few suggestions of highlights around the top edges of some of the petals indicate that the sun still has some strength.

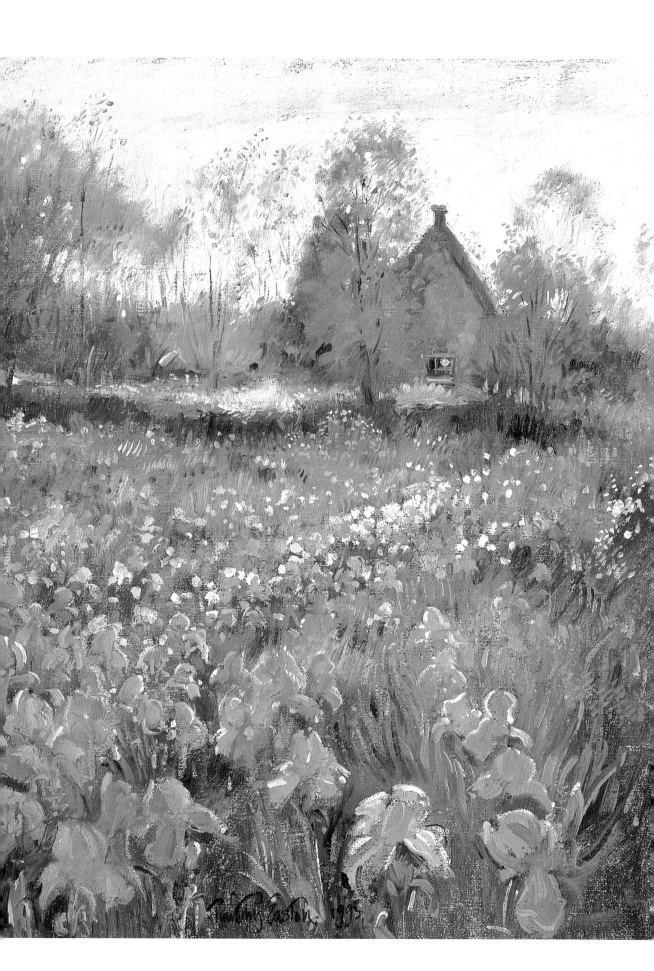

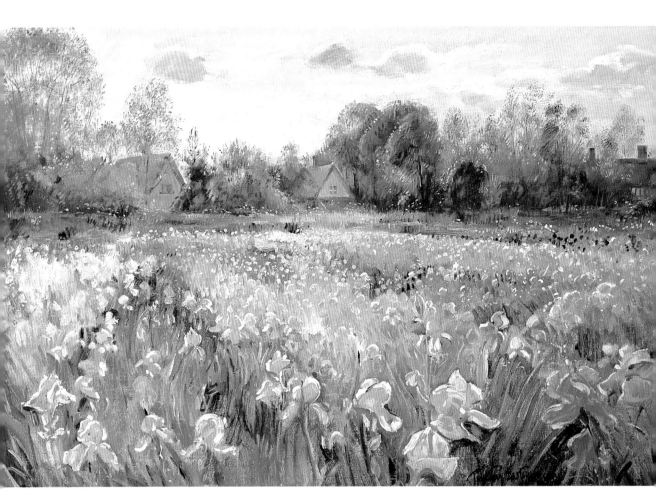

IRISES IN THE EVENING LIGHT 30.5 x 46 cm (12 x 18 in.)

ORGANIZING THE COMPOSITION

The picture shown here was painted between 8 and 10 P.M. The sun had dropped considerably and was almost directly in front. In this painting there is a broadness of approach to most areas of the flower field. Seen against the light, the irises appeared as a mass with highlighting confined to the edges (see also the detail on the frontispiece). I used various sizes of hog-hair brushes, with some lines or highlights added with a sable to provide definition and contrast.

We have examined various ways of controlling the viewer's perception of flowers by organizing the shapes and emphasizing those that are seen close-up against the middle distance. With a wider view and a greater depth of field, the next challenge is to use a composition that takes this all in and still retains a sense of focus.

For *Irises in the Evening Light*, the composition looks along views of flowers which could have pointed towards a vanishing point. However, these flowers have been wind-blown and the lines are therefore not so obvious. By emphasizing other patterns of light against shadows, a less regimented set of direction pointers lead from the centre of the foreground to the farthest edge of the field (see diagram opposite).

The diagram below simplifies the main features of the composition for *Irises in the Evening Light* and helps explain how they are organized. The blue irises in the foreground are positioned against the light and are seen as a block of blue, with yellow and mauve highlights to keep interest in the middle section. A V-shape is formed by the shadowed areas of two rows against the central yellow area. This opens up the middle distance and leads the eye towards the cottages. To take advantage of what is actually in front of you it may be necessary to adjust the height of some flowers or leave others out. This creates darker spaces which help to structure the composition.

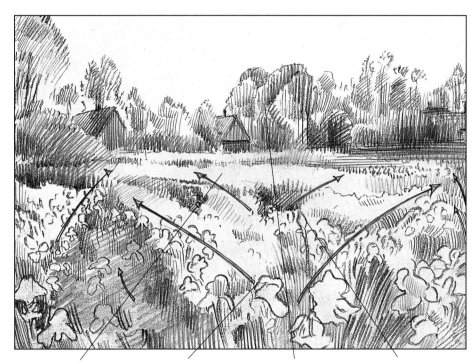

Against the light, the blue band of iris is seen as a block, with a few highlights of yellow-white and palest mauve to keep the eye moving along the middle section

A V formation, created by the shadowed areas of two rows against the contrasting central area of yellow, helps to open up the composition towards the middle distance with the three cottages

The trees are broadly blocked in with a hog-hair brush and a finer sable is used to create half-lights and highlights using dots and dashes (see also detail of this section on page 2)

The unopened flower acts as a pointer, rising from the V towards the dark patch, and directs attention to the widest blue band under the central cottage

Demonstration

A field of irises

Whether you decide to come in and focus on a section of a border or survey an expanse of massed flowers, try to select a subject that can be simplified into blocks of colour. Resist the temptation to work on detail, certainly in the early stages of laying out the composition, and try to select moments of the day which give you interesting light effects from the side or in front to help with contrast.

TIP

The cross-referencing of borrowed colour, picked up from the sky to fields and field to trees, ensures that you do not finish with two disconnected halves.

COLOURS
- **Yellows** – cadmium yellow and yellow ochre
- **Reds** – permanent mauve, alizarin crimson and burnt sienna
- **Blues** – cobalt blue and cerulean blue
- **Greens** – sap green and olive green

BRUSHES
- Hog-hair filberts sizes 2, 4 and 5
- Sable sizes 2 and 4

Method

1 The middle band of trees and buildings was quickly blocked in using limited colours. A network of cross-referencing lines was established to represent the bands of horizontal colour and the shafts of highlights across the rows; each of these leads towards one of the buildings. The sky was deliberately restricted to help make the field of irises the dominant feature.

2 The pale blues and light purples of the middle-distance flowers were laid down at the same time as the sky to establish reflected colour.

3 The foreground shadows were set out before any individual leaves were suggested in the painting.

DAPPLED LIGHT ON THE IRIS FIELD 28 x 48.3 cm (11 x 19 in.)

4 While some of the darker blue and purple blocks of irises were painted, the same range of colours was introduced to the tree leaves in shadow.

5 The pale pink streaks of dotted highlights, overlaying the darker blues, meet bands of colour going downhill. These help to draw the eye through the hedge gap and beyond to distant fields and hedgerows.

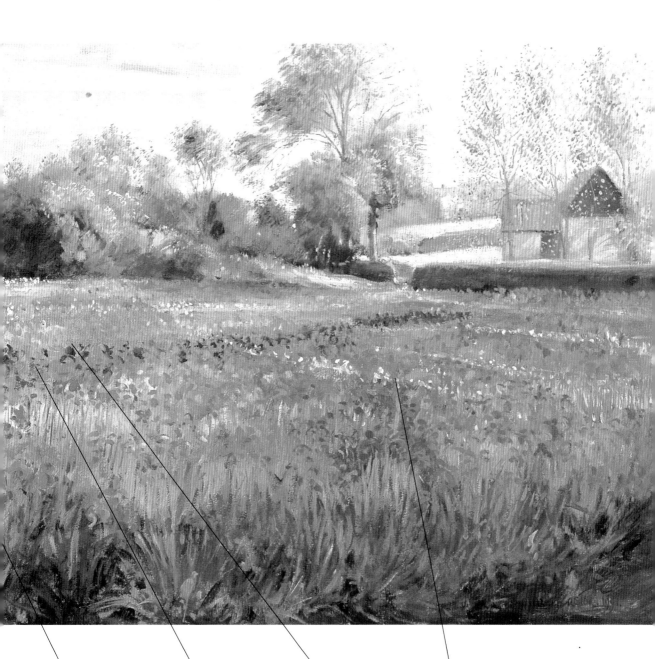

The play of complementary colours – purples and yellows, and blues and oranges – echoes the play of light and shade

Middle-ground flowers merge into areas of intermingled colours while the foreground flower shapes are more clearly defined

Blue iris flowers are mixed from cerulean and cobalt blue and a touch of alizarin crimson

Purple flowers are mixed from the same colours, with a touch of yellow and with greater emphasis on red

GARDENS WITH FLOWERS

TIP

If you would like to try
this sort of composition
out for yourself, find an
island bed and view it
with the light in front
or to one side. This will
help you see the
planting as a tonal
mass which will help
you resist putting in
the highlights until
near the end. Try to
divide the painting up
into large blocks of
dark and light.

Gardens usually have a formal structure which may act as a foil for the flowers. Unless you are going to isolate the individual plants, the first task is to look at the possibilities presented by paths, walls and hedges, which may help you create a sense of depth. Perspective may also play its part. Both examples on these pages have shadows cast over the foreground pathways, placing the main focus into the middle distance.

In the painting below, most of the forward border in the front is in shadow with small shafts of light cutting across the top of the clumps to leave dappled light patches on the grass. Flowers are massed and close in tone. The light breaks make short lines parallel to the angle of shadows and relieve the density of the foreground. Lilies in pots were positioned in the border to give some height and lighten the areas against the dark rose bush.

Green and yellow predominate and, as many areas are darkened for the shadows, lighter tones are introduced with reds and blues. The pink tones of sky, tablecloth and conservatory walls also offer a warm contrast. Finally, a yellow glaze over the lawn helps to focus on the lightest area around the table, set in preparation for a birthday tea party.

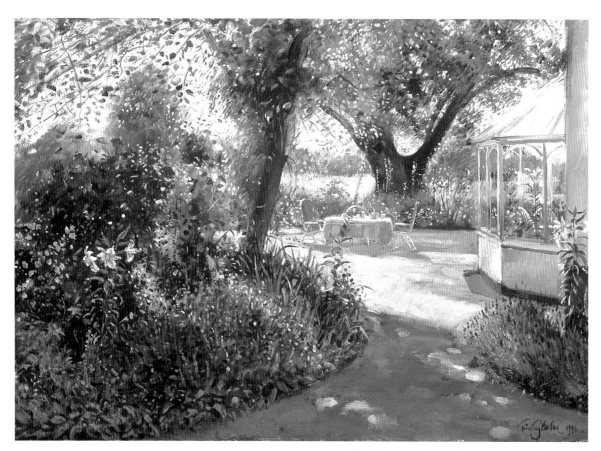

TEA UNDER THE GREAT OAK 30.5 x 46 cm (12 x 18 in.)

THE FORMAL GARDEN 40.6 x 51 cm (16 x 20 in.)

The clipped yew hedge of this painting offers a strong background to the side-lit border of herbs and plants. When you are faced with a mass of individual flowers, try to paint several tones down and then gradually work up to the brightest flower heads. Don't feel obliged to record them all, but arrange the lighter tones into patterns that make easy guide lines for the eye to follow.

NOTE

The planted copper container was set farther back, just out of view to the left side. By 'pushing' it into the picture, the diagonal shadow was used to shade the corner and keep detail recessed in the foreground.

Note also how I chose a similar parallel diagonal shadow made by the gateway on the hedge. This helps to sandwich the focal area on a diagonal to counter the pathway cutting across in the other direction.

MASSED FLOWERS

When it comes to painting individual plants in a cluster, I find the amount of detail required depends on the species of flower. Where possible, try to look for places where you can group or mass flower heads and perhaps use more detail in some key parts that offer a clue to the species. Certain favourites like irises have such a strong identity that they are as instantly recognizable at fifty feet as at five feet. Where smaller species like pinks or violets are concerned, the necessity for close work is likely to require a more detailed approach and for this reason I tend to include the small flowers only in still-life work and concentrate on bolder forms outside.

Shown here is a small *alla prima* painting made on a hot mid-summer afternoon using broad brushwork. It has light flooding over the purple-headed achillea plants, which are supported by canes. It illustrates how certain plants can have their form suggested with layered colour and little need for detail. The dark green gaps, where the stems and leaves show, do help define the outer shape of some flower heads and the canes make useful markers to help with the spatial depth of the composition.

Beyond the foreground bush in the painting shown opposite, a rose (Paul's Himalayan Musk) climbs vertically into an apple tree. The method of colour-blocking and highlighting was done in a similar way to the last example: blue-greys first for the shaded flowers and variations of a contrasting pink for those catching the light. These were worked together with the trunk and leaves of the apple tree and a willow behind so they form an integrated part of the backdrop, lifting the eye from the bush in the foreground to the distant trees.

TOWARDS THE GATEWAY 30.5 x 25.5 cm (12 x 10 in.)

Roses and Chinese Bridge 40.6 x 35.5 (16 x 14 in.)

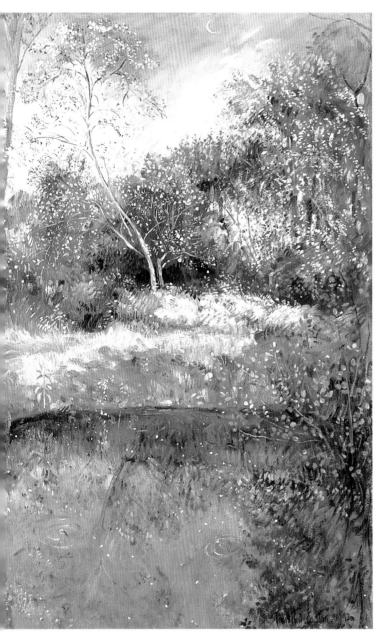

FLOWERING APPLE TREE AND CRESCENT MOON
40.5 x 25.5 cm (16 x 10 in.)

BLOSSOM

During certain seasons of the year there may be magical moments when a familiar landscape is transformed by a flush of pale-coloured flowers growing at a high level. Whether it is may blossom in spring or rampant climbing roses in summer, blossom provides an opportunity to extend the height of the flowers in your composition.

The dense flowering of vigorous climbers or cherry blossom gives me the opportunity to use thick pale impasto to suggest the luscious build-up of massed scented flowers. You can see this in the treatment of the flowering may bushes in the illustration on page 69. On this page, the spindly tree carries less weight of bloom, so I adopted a specular highlighting method to contrast with the broadly painted, deep blue-green bushes and trees behind. As with the previous two paintings, a mid-tone warm colour was placed first, contrasting with the darker leaves. This finally lightens up to create a pattern of dots, giving a sense of movement. This is echoed in the lower half, where the fallen petals scattered over the water carry these rhythms downwards. Notice as a contrast the broader treatment given to the other flowers – at the top of the bank on the left a carpet of blue speedwell leads into a horizontal band of frothy cow parsley.

The painting opposite uses a similar device, but the massed blossom fills the majority of the top half of the canvas.
The smell can be pleasantly intense, almost overpowering, and I was keen to communicate a claustrophobic feeling by limiting the sky area and using thick impasto to give due weight to the flowers.

(Opposite) MAY BLOSSOM AT THE MOAT EDGE
40.6 x 30.5 cm (16 x 12 in.)

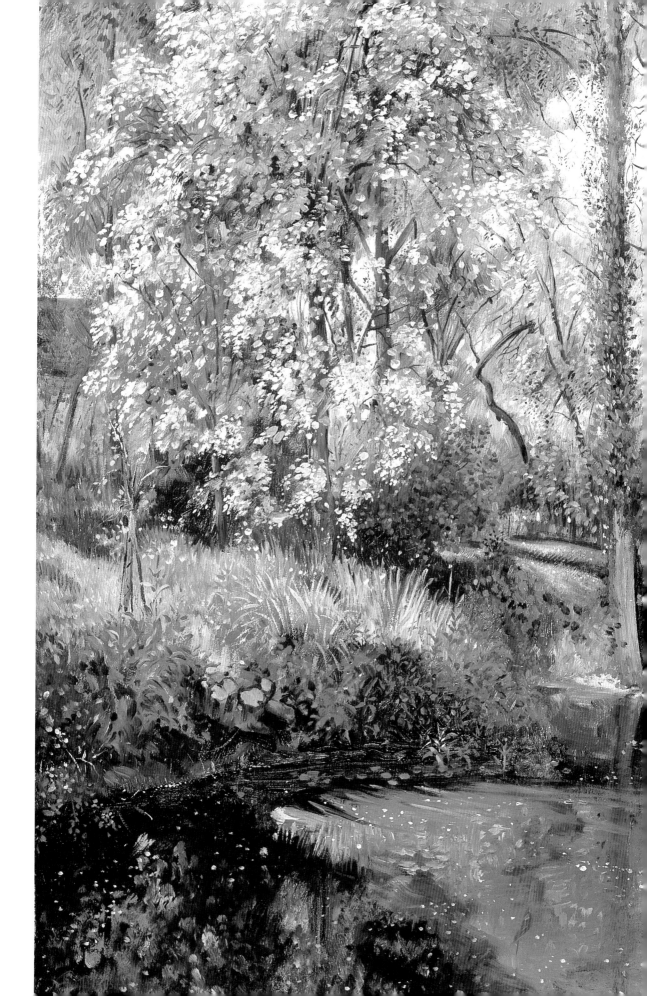

Demonstration

Painting bold flower shapes

This is a more elaborate composition, though it uses the same starting principles as the irises study on pages 58–9. It took about four sessions to complete. On a larger scale, there is no less definition to many of the individual iris heads, but they are contrasted with clusters which are grouped in close colours and tones and are more broadly treated.

COLOURS
- **Yellow** – cadmium lemon and raw sienna
- **Reds** – cadmium red, alizarin crimson and burnt sienna
- **Blues** – cobalt blue, cerulean blue and ultramarine blue
- **Greens** – viridian and sap green

BRUSHES
- Hog-hair filberts sizes 2, 3 and 4
- Sable brushes sizes 2 and 4

Method

1 The structure of this composition uses an inverted pyramid, starting with the closest pink flowers. The splay goes out on each side until the path is reached, which links and completes the triangle.

2 The blue irises, being the dominant colour, were laid in, with the greens worked around. The purple flower heads were painted against the darkest corners at the bottom.

3 The path was put in with the green leaves overlaid.

4 After establishing the V-shaped formation of pink flowers in the foreground, the olive green herb was positioned as a central anchor.

5 Finally, the outer crimson and yellow flowers were put in and the clusters were worked up to give some definition and highlighted accents.

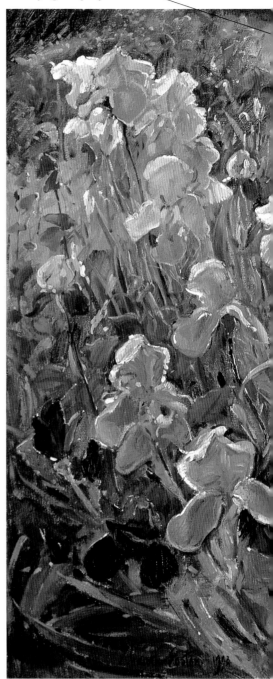

By emphasizing the warmth of the reddish-pink path it acts both as a contrast with the mass of green and a link with the foreground pink flowers

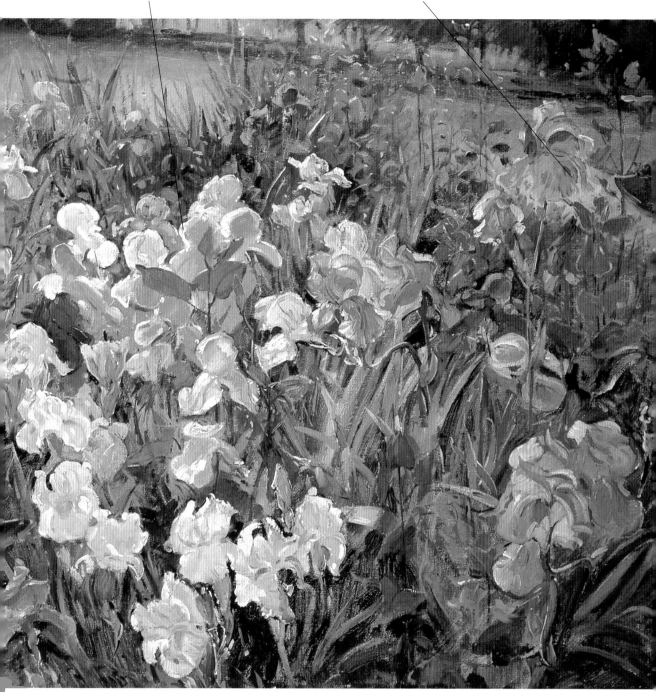

Highlights on edges of the flowers are created with a mix of the palest pinks and yellows for contrast and definition

Edge flowers are deliberately created with darker tones so the eye is not drawn to the sides of the canvas

THE IRIS BED 61 x 76 cm (24 x 30 in.)

Still Life

The advantage of working with still life is that it gives a large degree of control over the conditions. You can manipulate selected objects to help you to understand more about colour relationships, space and related forms. You can also experiment with different kinds of lighting, both natural and artificial, which will help you to create three-dimensional space on your two-dimensional surface.

In selecting your subject you will naturally first consider objects that are attractive to you, perhaps moving on to think about the scale of one object in relation to another to create balance in your composition. As most still lifes are set up and studied within the interior, why not try hanging transparent fabrics in front of a window and incorporating pieces on any ledges or sills to extend the composition of your subject upwards. When a window is used in this way, any bars will provide a strong architectural grid which could help structure the painting.

Consider also ways in which you could link the objects. With a strong light source, cast shadows will play an important role and can make interesting connections between objects. I often lay various pieces of toned paper or material over one another. Apart from giving a base of interesting shapes, this can also help with perspective. A striped tablecloth can give the same effect.

TONAL BALANCE

It is understandable that most people see the colour of objects, and the way these relate to each other, rather than their tonal value. Tonal values are the shades between black and white. A still-life group reproduced in a newspaper photograph would give a tonal reproduction, but this is not the same as light and shade. A bright colour in your still life will not necessarily have a high tonal value. A Claude Glass will help you understand the different qualities and gradations of tone and with practice, looking through half-closed eyes, such distinctions become clearer. As an exercise, why not draw your still life in charcoal or pencil or make a monotone painting study focusing on tone? This will help you make an assessment of the weight of darks and lights in a composition.

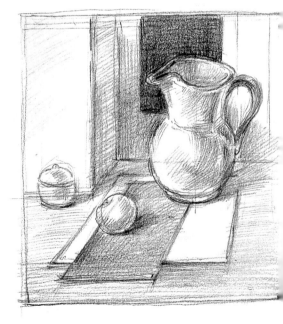

Diagram showing tonal balance

EXERCISE - BUILDING A STILL LIFE WITH FLOWERS

Shown here is an approach to understanding the form of some flowers in a glass jug. I started by selecting three or four of the principal blooms as my focal point and then related these to the bigger group. I have chosen to do this as a drawing in line and tone. The principle would be similar if you were building up a painting, as it is always wise to establish the form and balance in charcoal or with a monochrome paint wash before applying thicker paint and colour.

A sketchbook drawing made before beginning a painting can sort out the balance for the composition and help you decide what areas of background to include around the outer edges. While going through this process, you will also have an idea of the most appropriate dimensions and proportions for the canvas.

Consider what sort of background colour would best reflect the mood of the painting. A close-toned colour can, with subtle sidelighting, help the flowers to emerge from the shadow, whereas a complementary glowing colour could emphasize the overall shape (see the similar exercise on pages 58–9).

The arrangement shown in this painting uses the same glass jug but contains pinks and cornflowers. Note how the few heads that are not directly lit are less detailed than those nearest to the viewer. When arranging flowers for a painting try to get away from the formality typical of a flower show. It is better to limit your range of flowers and their colours, maybe even using one main colour with one or two contrasting flowers that give the painting a richer punctuation. To achieve a more natural look, make your flowers overlap with others that extend outwards or downwards from the central area. This will give a sense of space around the outer edges.

The flowers farthest away are lightly outlined and incomplete, whereas the foreground flowers are finished in line and tone to show proportions, relationship and tonal balance.

1. *First stage, setting out proportions of central flowers.*

2. *Building up with line and tone to give form to the related flowers.*

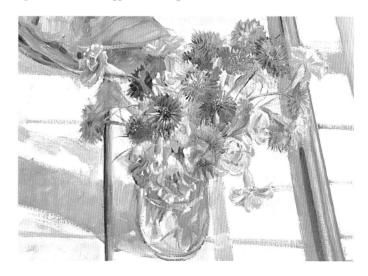

3. *An expanded view of auriculas in a glass jug.*

PINKS AND CORNFLOWERS (detail)

A similar arrangement of pinks and cornflowers in the same glass jar, some of those on the left and at the back are not in full light so are less defined than others more directly lit. Each block of colour is balanced against another to suggest the changes of form within each flower.

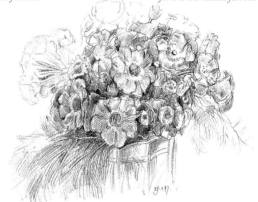

SIMPLICITY AND CONTRAST

TIP

You could research
ways other artists have
tackled their subjects
by making some simple
freehand drawings
using book illustrations,
or even make a line
tracing to see how the
shapes and shadows
are balanced.

A painting which includes objects you feel strongly about is bound to give an added sense of purpose. Experiments and experience will teach you how to set such objects up to make an interesting composition.

You will find your viewfinders useful for deciding what angle to take. From a high viewpoint, you will be able to use the positioning of objects of similar size to emphasize a regular pattern as you can see in these two examples. From a lower point, you can give an impression of depth by overlapping objects which get smaller and less focused as they recede from view. Starting with a simple composition will allow you to exploit these aspects.

The linear patterns of the tiled floor in this study make a strong grid for positioning the loose fruit and basket. The modelling is enhanced by bringing out the reflective areas within the cast shadows and on the fruit itself. The diagonal lines made by four of the apples, the sunny reflection from the window and the angle of the basket's handle overlapping the receding perspective of the tiles help describe the spatial depth.

I chose to paint this in a high key to suggest the warmth of autumn and used touches of a complementary green colour around the composition to give a further sense of movement and contrast.

THE APPLE BASKET 46 x 51 cm (18 x 20 in.)

APPLES AND CHERRIES 25.5 x 30.5 cm (10 x 12 in.)

This study was painted on two hot afternoons in high summer, so I chose a cool white-on-white colour scheme. As the cast shadows made a range of strong blues, the light areas of pale yellows and pinks laid against them form a strong contrasting pattern. As with the last example, the diagonal shadow areas overlay the perspective lines of the tablecloth.

This is a simplified diagram showing the apple basket group seen from a lower viewpoint. The overall pattern is not so evident in the composition and there is more reliance on the overlapping of objects to create a sense of depth

SIDE LIGHTING AND SHADOW

A changing light can affect the spatial depth of a building in the landscape (see page 17). With a still life, you can move your objects through and around a light source and take full advantage of dramatic light effects. In both the examples shown here, the strong side light creates opportunities for exploring the silhouette. In a warm room tulips tend to splay outwards to create interesting spatial patterns. The shadows formed by a side light make exaggerated patterns that become as important as the objects themselves.

This is a painting that explores the possibilities of pattern rather than a description of flower forms. Many of the flowers in the upper half of the picture have nearly the same tonal values as the background and it is the shift in reds and yellows against the warm greys that

distinguish them. Those in the lower part of the arrangement are more strongly silhouetted for contrast. The flower heads are quite loosely painted without much descriptive detail.

This diagram for the painting below shows a simple use of the light and dark masses. By shadowing the top half of the picture diagonally and using the pattern of the shadows from the jug and window bar to divide up the sunlit area, a strong abstract pattern is established against which to set the tulips

TULIPS AND RAKING SUNLIGHT 30.5 x 35.5 cm (12 x 14 in.)

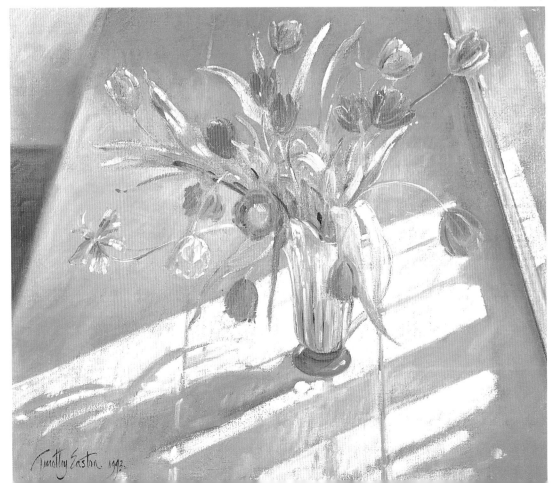

The painting below shows the process reversed, with some of the flowers on the upper left forming silhouettes and the right-hand tulips being similar in tone to the background.

The shadows of the window arches are used here to echo and complement the curved stems of the flowers and create sinuous lines across the composition. Because these flowers are more front lit than the tulips opposite, the paint is built up to model the forms. I had to pick on exactly the right moment to define the position of each tulip as they tended to adjust themselves in the heat and light.

On the first day, I painted the blue tiles and the window reflections using darker colours than those you see here. The lighter toned colours were scumbled in the next day with some of the darker paint showing through to give visual depth to this area. A similar method was used for the table top.

Diagram showing the underlying geometry

The accents on curvelinear forms help release the arrangement of the grid structure from the more formal geometric structure

Spring Flowers and Window Reflections
30.5 x 35.5 cm (12 x 14 in.)

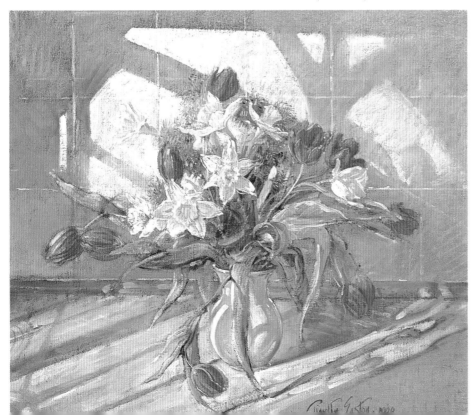

OBJECTS IN A ROOM

Still life painting does not have to include just the obvious subjects like a jug, flowers or a piece of fruit. Anything that can be shifted or arranged, from machinery to driftwood, can be incorporated to make exciting shapes or colour relationships. It may be that you see a group of objects in a friend's house and this sparks off an idea to try out. This is when a small drawing book will be useful to jot down ideas.

Some artists like to stage the arrangement of the objects, but I will often be inspired by a still life group encountered by chance. Maybe this is a group of toys or clothes or a flower arrangement that has been put together by somebody else for quite a different purpose. This kind of subject can offer you a new perspective and a refreshing, individual approach.

The objects in the room shown in the picture below are not particularly

remarkable, but their relationship to each other and the large window eloquently describe the nature of the space in this large seventeenth-century hall.

The diagonal lines linking the two orange trees, the back of the cane chair and the geraniums are echoed in a set of parallel lines formed by the floor tiles. The other set of diagonals at right angles, together with the two light breaks and the shadows of the window-bar on the shutters, direct the viewer to the right edge of the window which is placed centrally across the width of the canvas. The horizontal glazing bars hold the eye and allow the garden to be absorbed into the composition. By shadowing all the objects, except some highlights on the leaves and petals, the exterior is given as much importance as the interior space. Each of these reflects the environment of its owner.

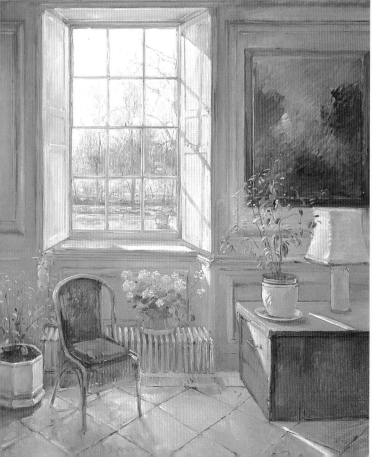

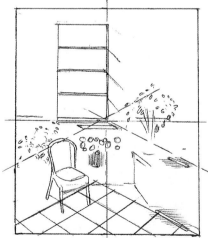

(Above) Sketch showing how parallel lines through principal objects meet at the centre of the painting and are roughly parallel with the edge of the floor tiles

(Left) SPRING LIGHT ON ORANGE TREES
91.5 x 71 cm (36 x 28 in.)

BELLA'S WINDOW 76 x 61 cm (30 x 24 in.)

In contrast to the last example, all the objects in this painting are well lit. The source of the light is directly in front, so that the shadows cast by the mullions and the box create a perspective that draws you into the picture. This extends down the path and over the bridge, but the aerial perspective blurs this background to keep the focus on the foreground details. The painting is helped by the strong, underlying grid of the window, but the curtains, costumes and kite help to soften the edges.

I discovered this window arrangement in my daughter's bedroom and because this painting was to be a record of someone's personality, reflected through their choice of objects, I decided to opt for a large view in the style of a portrait.

TIP

An alternative way of approaching a subject with many elements would be to isolate and concentrate on small sections first.

STILL LIFE 83

PAINTING COOL INTERIORS

By mid-summer, I have been painting outside for several months and the landscape has turned a dark green. I sometimes find it a pleasurable change to come inside while the light is still bright and paint a cool picture. Here are two examples where the outside view is deliberately obscured so that the emphasis is entirely on the objects and shadows. Try hanging a piece of muslin over the window frame; this will create a glow against which the objects are silhouetted. If there is plenty of sun outside, reflected light will enable the colours and forms of the focal objects to be understood and painted.

By contrast with the last picture *Attic Flags* is intentionally more spartan, and the shadows are as important as the objects to define the space. Apart from the strong red and blue flags, the amount of colour used is relatively limited with emphasis given to the texture of the paint. The effect that I aimed for was the opposite to the warmth of the picture on page 83. This is an empty room devoid of personality, where the contents of a long-abandoned dressing-up box could be discovered and the room suddenly transformed into a play area. The composition is underpinned by a pyramid shape formed by the shadow of the window, the main string of flags and the shadow cast by these and the chair.

ATTIC FLAGS 61 x 51 cm (24 x 20 in.)

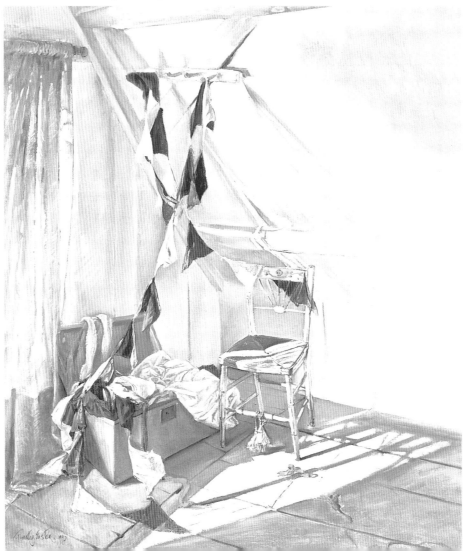

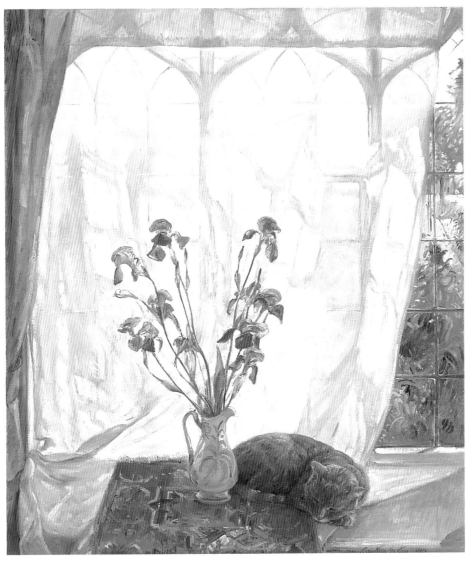

IRIS JUG ON THE TRIBAL CARPET 61 x 51 cm (24 x 20 in.)

MANIPULATING THE LIGHT

The play of light and shadows on the curtain featured in this picture was as important as the still-life objects. The pattern created by the shadows of the window bars becomes an extension of the sinuous iris stems coming out of the jug.

The technique used for the translucent area of curtain was dry brushing. By continually dragging 'dry' paint over and over, light against dark, introducing touches of colour other than pinks and blues, a veiled effect was finally achieved. These applications were done over several days, sometimes letting the paint dry completely.

When I am working, I find that my cats are both predictable and persistent. If I am painting something near a window on a warm day they will insist on sitting among the objects, particularly if there is a carpet provided. Once the invitation is extended, they will come back to the same spot day after day and sleep quite still for long enough to be treated as part of the still life.

SEASONAL MOODS

Light shining through
flower petals does not
give the same
contrasting shadows as
side-lit flowers, so may
be less easy to paint.
You might find that
more densely petalled
flowers in a mixed
group will be initially
easier to tackle when
painting into the light.

The winter and spring, when it is too cold or windy to paint outside, are good seasons to take advantage of a light which is often strong and inviting on an interior setting. I often set up a window still life with flowers or objects that are seasonal and which might reflect or contrast with the external colours.

A few objects placed at some distance apart would not normally make a successful still-life group because it would be difficult to give such separated objects

any visual impact. However, in this instance, strong and interestingly shaped shadows are the important ingredient that makes them work as a group. By choosing cool colours within a large space and showing part of an open window with a glimpse of dark-toned foliage, the coolness of the interior is contrasted with the heat of a summer day. None of the white areas is in fact white; touches of green and yellow are added to give emphasis to both the cool and the warm passages.

LILIES AND STRAW HAT 35.5 x 46 cm (14 x 18 in.)

In warm weather, with a window opening onto an attractive view, there is a strong invitation to go beyond the window frame and into the landscape. You will need to make a decision about which part to concentrate on, remembering that the eye cannot focus on all the information with the same degree of clarity.

This small simple picture opposite, with spring flowers and willow branches just beginning to shoot, is set against a lawn and large pond. The water disturbance made by the wind blowing across the pond is echoed in the forms of the twisted willow branches snaking out of the glass vase.

WILLOW BRANCHES WITH NARCISSUS 25.5 x 20.3 cm (10 x 8 in.)

Painting glass may seem a difficult subject, but try to see the tones first, and leave out any highlights until you have nearly finished so you are painting in blues and greys. When you come to add the highlights, mix in a touch of yellow or blue with your white. The distorted stems can be painted in much the same way as the reflections in the *alla prima* demonstration on page 34.

The Chinese lanterns were added to give a touch of warmth and for their interesting double shadows. They sit so lightly on the sill, giving the impression that, if the window were opened a crack, they would blow away in an instant.

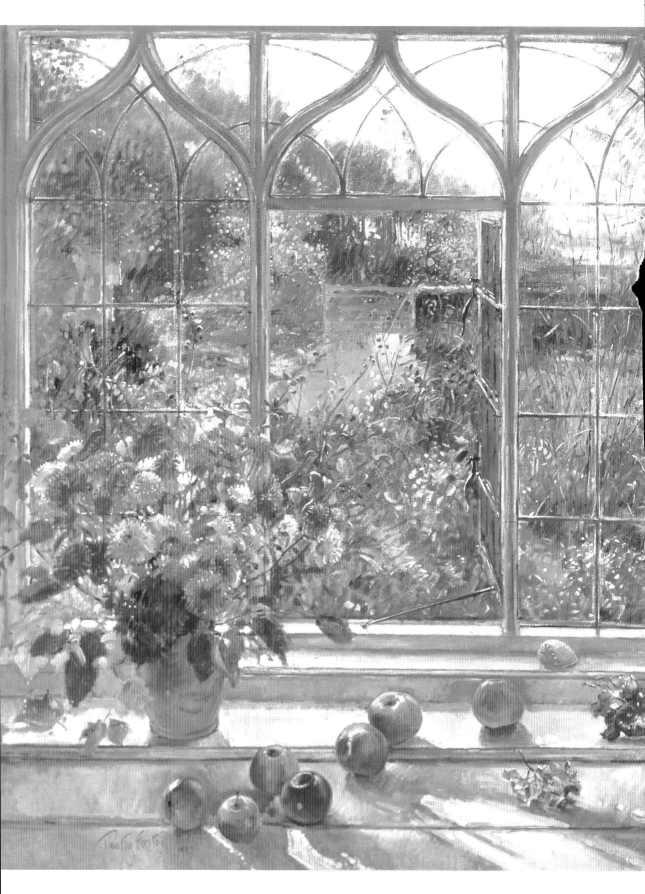

COMBINING A WINDOW GROUP
WITH THE VIEW BEYOND

The red autumn foliage in this group opposite, which had replaced the green summer leaves, made me want to capture the warm, rich colours. When there are no dramatic variations in light in a garden or landscape such as this, the tonal differences between foreground and middle distance are only small. In this case, the apples snaking up towards the open window encourage an exploration of the central view towards the gate, but the margins of the landscape are broadly treated in order to emphasize the window sill where the foreground group is the main feature of interest.

Much preparatory measuring and drawing on the canvas was necessary to set out the proportions of the window grid and related sill and table below before any colour was applied. A plumb-line is a help in establishing the vertical marks and a wooden rule can be helpful to measure and correct the lines. As you start to paint, many of these marks will be covered, but you can leave enough suggestions to use as reference on the newly painted surface.

If you feel that a composition such as this is too ambitious, try something similar by isolating the group that occupies the bottom left-hand quarter. The green background seen through the flowers gives the deep reds and oranges an extra richness. The overlapping of many of the flower heads helps create spatial depth and the higher colours of the yellow and pink blooms break up the dark mass, giving a sense of rhythm within the structure. With dense petalled flowers like these, you can begin with very broad marks. Resist the temptation to put in detailed petals until you have an overall arrangement of colour, form and tone established.

TIP

When applying central masses of green leaves and stems coming from a container, put the colour on broadly and break up the area with dots and dashes to represent the background which can be seen through the gaps. The underside of the lemons and jug in the study below are painted with thicker paint than the washes used for the darker underside and this makes the lemons sit on the surface convincingly.

By comparison, this winter study shows a marked tonal difference between the still life and middle distance. The flowers and fruit could have appeared more silhouetted, but further light was reflected from another window and the rich glowing colours contrast strongly with the blue shadows. Sunlight reflecting from snow will in turn illuminate the ceiling above the still life and should create a fair amount of top light. As an echo of the colour resonates in the still life, the warm pinks of the sunlit church tower are similarly balanced against blue shadows.

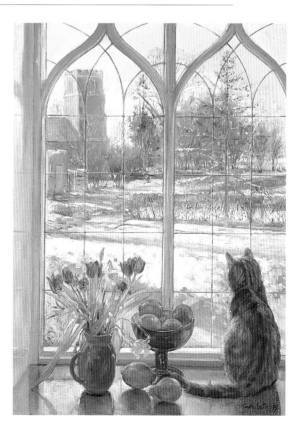

(Opposite) Autumn Window 51 x 61 cm (20 x 24 in.)

(Right) Snow Shadows 40.6 x 25.5 cm (16 x 10 in.)

CREATING MOOD

The objects in the painting below were put together to celebrate the owners' love of their garden and the countryside. The decoration on the crewel work cushion establishes a link between the sculptural qualities of the lily and the flower border seen through the open window.

The applications of paint texture change from the use of dry, almost dragged, pigment for the foreground details to the looser use of paint with small specular highlights in the herbacious borders. This change of scale in the brushmarks is another device that can be used to suggest distance.

I particularly enjoy the effects of strong sunlight falling across or behind objects, but there are also ways to use limited light to set up the mood of the day or the time of year as illustrated in these two very contrasting pictures: the one opposite creating the illusion of moonlight and the one below recalling the feel of very hot days when an inner curtain might be drawn to shade an interior.

The composition in the picture opposite was not deliberately set up for a painting, but I saw it in our kitchen window one evening in July just as the light went down. The white painted surface was sufficiently reflective to keep the interior 'alive', but I decided that I would need some help with an internal light to work by. Some of this secondary lighting would filter out and help to lift the colours of the flowers and fruit. The painting was set up and started when there was plenty of light and then worked upon during that halfway stage when the sun has disappeared over the horizon but the light glows for an hour or more before the sky becomes completely dark.

The reflected interior light reversed the tonal qualities of parts of the window, so the mullions are pale and the sky is a darker rich blue. The glowing exterior light is sufficient to indicate the position of hedges and a tall angelica plant outside, just behind the jug of flowers, without distracting from the interior focus.

(Below) Lily and Window Seat
51 x 61 cm (20 x 24 in.)

(Right) Moonlit Flowers
61 x 40.6 cm (24 x 16 in.)

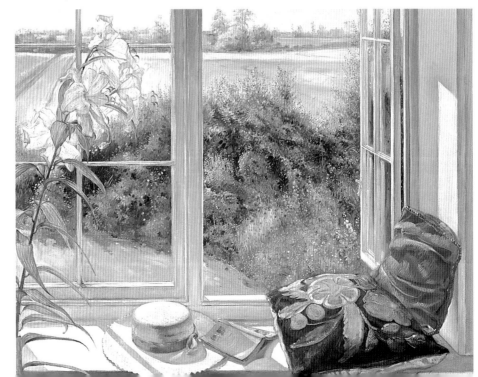

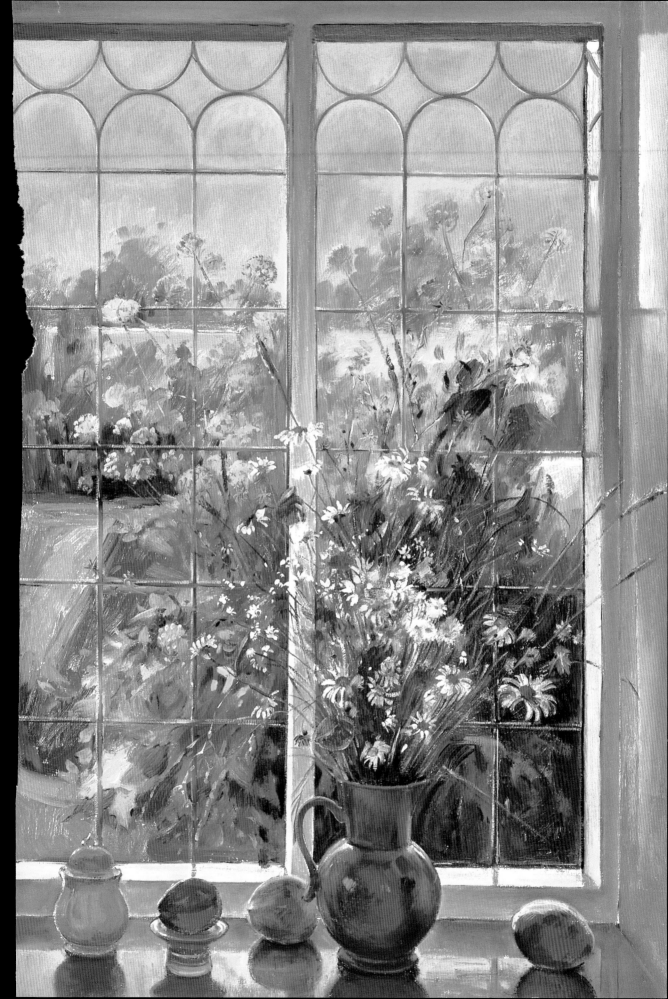

Demonstration

Painting a still life in strong sunlight

A group of objects lined up across a window sill may not seem a promising subject at first, but the strong effect of sunlight flooding in from the other side will give the essential extra ingredients – strong shadows and highlights on objects. Spaces between objects should be treated with equal importance to the objects themselves as they are important for setting rhythm and mood. In this painting, the shadow cast by the window makes direction lines that draw you to the window front.

COLOURS
Yellows – cadmium yellow and raw sienna
Reds – burnt sienna, cadmium red and alizarin crimson
Blues – cobalt blue and cerulean blue
Greens – olive green and sap green

BRUSHES
Hog-hair filberts sizes 2, 3, 4, 6
Sable sizes 2 and 3

Method
1 Choosing how much of the window to depict and what area to show around it was governed by the space that the outer objects occupied and their appearance. Setting out the vertical and other perspective lines was done approximately so that tone and colour could be laid out to get a balance of dark and light areas by the end of the first session. Remember that you can always come back at a later stage to readjust the verticals and horizontals.

2 The central objects were put down with the foreground grid and shadows. At this

stage it is best not to go for the full strength of light against dark so that you leave room to increase this effect when the painting is more advanced. The balance between the blue tiled side walls and the shadowed areas of the drive outside was next established as this helped to consolidate the tonal values of the lower half of the composition. (Although direct lighting for the central area will only be available for about an hour, the tonal values for the

THE IGNORED BIRD 51 x 61 cm (20 x 24 in.)

surrounding areas of the walls and ceiling should stay reasonably stable for two or three hours in summer.)

3 The garden was painted in broadly without too much definition, so as not to distract from the focus on the still life. If the perspective of the building outside were more defined, this could lead to confusing conflict with the false perspective of the front window shadows.

4 Towards the final stage, the contrast of light to dark areas was increased to emphasize the important passages. Against the predominance of blues and greys, the yellow fruit is the brightest colour although not the highest in tone. The shadow grid is varied in its intensity of blue-greys and some lines appear 'broken' to make these look less mechanical. The highlights of the objects were kept subdued until the last stages when a rhythmic pattern could be set up.

VARNISHING AND FRAMING

Varnishes

Varnishes are applied to an oil painting when the paint is dry in order to protect the paint layer from dirt, dust and smoke. As a general rule this should not be done for at least a year, but since certain paints may take many years to dry out fully, this does create a dilemma. Despite the development of improved varnishes, in my opinion there is no varnish that does not have some disadvantage. From the traditional natural resin varnishes, mastic and dammar are perhaps the safest. Ketone is a synthetic resin varnish which is sometimes preferred for its non-yellowing properties. Although placing an oil painting behind glass can detract from the impact of a painting, this may still be regarded as the safest solution.

Frames

Finding the most suitable frame mouldings and finishes for paintings is not an easy task. There is a vast range of pre-finished mouldings that are cut, mitred, glued and nailed. These are ideal for prints and watercolours, but tend to be less satisfactory for oil paintings. Alternatively a large moulding section can be used, which come either in natural wood or coated with gesso. These are assembled before the frame is painted, stained or gilded by hand and are more expensive because of the intensive labour involved. Artists and dealers can be secretive about the bespoke framers they use, so you may need to experiment before finding one that you are happy with.

BIBLIOGRAPHY

Max Doerner, *The Materials of the Artist*, Harvest/Harcourt Brace, 1984.

Ralph Mayer, *The Artist's Handbook*, Viking, 1991.

Keith West, *Basic Perspective for Artists*, Watson-Guptill, 1995.

LIST OF SUPPLIERS

Suppliers with free mail-order catalogs:

Daniel Smith Inc.
4150 First Avenue South
Seattle, WA 98134
Toll-free: (800) 426-6740

The Italian Art Store
84 Maple Avenue
Morristown, NJ 07960
Toll-free: (800) 643-6440

The Jerry's Catalog
Jerry's Artarama
P.O. Box 58638J
Raleigh, NC 27658
Toll-free: (800) U-ARTIST

New York Central Art Supply Co.
62 Third Avenue
New York, NY 10003
Retail store: (212) 473-7705
Telephone orders:
In New York State: (212) 477-0400
Elsewhere, toll-free: (800) 950-6111

Pearl Paint
308 Canal Street
New York, NY 10013
In New York State: (212) 431-7932
Elsewhere, toll-free: (800) 221-6845

Utrecht Art & Drafting Supplies
33 Thirty-Fifth Street
Brooklyn, NY 11232
In New York State: (718) 768-2525
Elsewhere, toll-free: (800) 223-9132

INDEX